Madelene M. Sheehan
Mar. 20- 2007

D0578624

Madelene M. Sheehan
Mar. 20- 2007

Shanghai:

China's Bridge to the Future

Shanghai:

China's Bridge to the Future

Chinese edition © 2005 Shanghai Literature & Art Publishing House
English edition © 2005 Shanghai Literature & Art Publishing House and
Shanghai Press & Publishing Development Company

The Reader's Digest Association, Inc., is the authorized publisher of the
English language edition outside China.

All rights reserved. Unauthorized reproduction, in any manner, is
prohibited.

Reader's Digest is a registered trademark of The Reader's Digest
Association, Inc.

U.S. Project Editor: Marilyn J. Knowlton
Project Designers: Yiping Yang, Naiqing Xu, Zongpei Jia
Interior Designer: Yinchang Yuan
Cover Designer: Mabel Zorzano
Senior Designer: George McKeon
Editors: Dolores York, Longgen Chen, Ying Wu
President & Publisher, Trade Publishing: Harold Clarke

Text by Chen Danyan
Translation by Sylvia Yu, Julian Chen, Christopher Malone
Introduction by Christopher West Davis

Library of Congress Cataloging-in-Publication Data

Chen, Dayan.
Shanghai: China's Bridge to the Future/Chen Dayan
 p. cm.
ISBN 0-7621-0640-9
1. Shanghai (China) – Pictorial works. I. Reader's Digest Association. II.
Title
DS796.S243C44 2006
951'.132'00222 - dc22

 2005050439

Address any comments about *Shanghai: China's Bridge to the Future* to:
 The Reader's Digest Association, Inc.
 Adult Trade Publishing
 Reader's Digest Road
 Pleasantville, NY 10570-7000

Printed in China

1 3 5 7 9 10 8 6 4 2

Contents

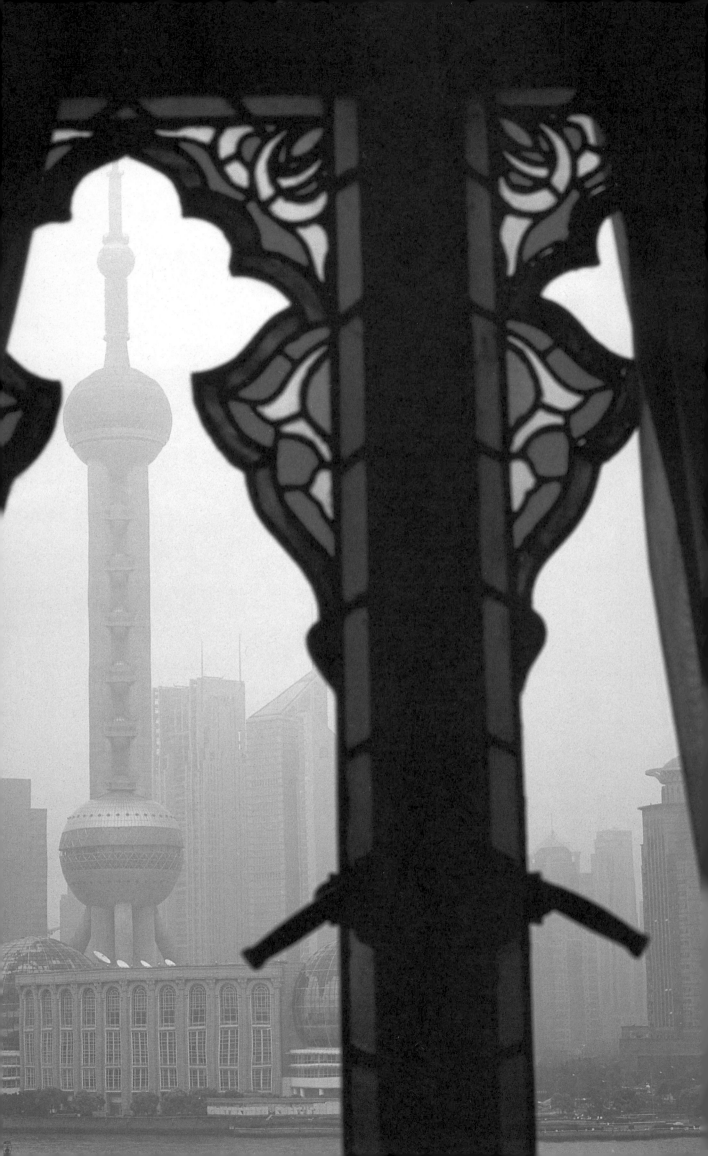

INTRODUCTION

There is an unspoken rule in Shanghai: If someone does not wish to speak, you don't make him. But rules, as they say, are meant to be broken.

Author Chen Danyan has made a career out of helping Shanghai reveal its untold stories. Her name and work have become synonymous with China's most bustling and futuristic city of 13.5 million (and growing). Her writings, like the city itself, are resplendent with the kind of delightful contradictions that spark and sparkle in the telling. At the age of 46, she has already produced an impressive number of books—most anchored in Shanghai. And while she has won numerous awards and critical acclaim, she shrugs off the role of star and celebrity, and has claimed in interviews that she still feels like an outsider in Shanghai (she was born in Beijing)—just another one of the city's millions of "immigrants" still, after 40 years, undergoing a patient process of assimilation.

Having been born in Beijing, Chen Danyan has no "blood link" to Shanghai, no inherited loyalties or taboos, no burden of family lore or preconceptions to shoulder. She has been free to discover anew, over and over again, the secrets of this marvelous city. It is a further happy irony that it was only after traveling to the great cultural capitals of the West that Chen saw Shanghai for the first time. For while much of China—and East Asia for that matter—looked to Shanghai as the most Westernized city in the region, she came to see that identity for what it was—an impression that existed only on the surface. There was much more to Shanghai than its talent for mimicking the West.

Spend a few minutes with Chen Danyan exploring the seemingly blank and bland façades of old buildings and worn sidewalks of Shanghai, and you begin to get the feeling that no secret can hide for very long from her. Like a forensic anthropologist squeezing as much evidence as possible out of the things everyday people overlook, she puts her extraordinary gifts to the task of ciphering out the clues in details as mundane as the scratches from crystal glasses on a bar. She eavesdrops on the shadows of history and makes them face up to the legacy they have left behind. Messages are everywhere waiting to be read.

In Chen Danyan, Shanghai has found a worthy biographer. And in Shanghai, a major talent has found a fertile and ever unfolding source of inspiration. She has acknowledged in interviews the strong influence Sigmund Freud has had on her art. She has also confessed that many of her observations are "archaeological fantasies," as if she sometimes catches herself trying to read too much into too little. She still pulls from her palette stunning, often haunting images: A warm summer breeze arrives and caresses the night like the strains of an accordion in a romantic French ballad; a café waiter, trying to be as Western as possible, wears blue-tinted contact lenses; and while most Western-style architecture looms as monuments to Western exploitation, a certain tower overlooking the river is like a flirtatious and sophisticated woman—able to preside with dignity over important occasions, weather any crisis, and,

when called for, charm and flirt with the best of them.

Chen arrived in Shanghai in 1962, when she was four years old. By the time she started primary school, the Great Cultural Revolution was under way. Young Chen had a stutter that made socializing at school a difficult challenge. Later she would hear one doctor's theory about stuttering—it was a sign that a child's intellect was developing at a rate faster than her physical development could keep up with. Whatever the cause, the speech impediment did have a silver lining—it made Chen determined, at a very early age, to become a writer.

As if paralleling her schooling, the Cultural Revolution came to an end when Chen graduated from high school in 1978. In the period of transition that ensued, she enrolled in East China Normal University. It was a time, she told one interviewer, "of intellectual liberalization," when "young people were obsessed with the outside world and Western culture." She studied literature, falling under the spell of the novelists of the French Enlightenment. It's not hard to see how young Chen would feel a kinship with a hero like Voltaire's Candide—someone who knew all about trying to hold on to an abstract philosophy while getting pounded by misfortune.

She soon went to work on her first novel, A Girl, drawing on the love and support she and her family had shared surviving the uncertainty and turbulence of her childhood. The story struck a nerve, not only in Shanghai. A Girl went on to be translated and read all over the world. Among the various accolades it received were the Austrian National Golden Award for Children's Books and, in 1997, UNESCO's International Gold Prize for Tolerance of Children and Young Adults.

By then Chen had already set off on an intellectual pilgrimage that took her to western Europe, Russia, Japan, and the United States. She learned something about traveling, that a journey is only part destination, part wandering. "Not to look at the outside world," as she once said, "but to stand in front of the mirror that is the world and find myself." In Germany and France and Italy she found an abundance of links to her childhood—from children's games to artistic sculptures, everything imitated and transformed, flawed through copying in China but nevertheless familiar. The world was a much more intimate place than the young pilgrim had ever imagined. There were threads of connection everywhere she looked.

Ironically, it was that experience that inspired Chen Danyan to return to Shanghai, her Shanghai, and write about a city that, like her, had absorbed foreign influences but at its core, on deeper inspection, had retained untainted its own unique and thriving cultural heritage. Her journey is still under way, and like a winged, high-soaring migration, it always brings her back to Shanghai to discover it anew. As T. S. Eliot wrote:

> We shall not cease from exploration
> And the end of all our exploring
> Will be to arrive where we started
> And know the place for the first time.

And what is Shanghai like today? The tallest buildings in the world; two breathtaking bridges; the world's most high-tech stock exchange; countless shopping opportunities that put Rodeo Drive to shame. America's influence is most apparent in the movies and Jazz music. Countless stores have sprung up selling coffee and perfume, Japanese or German cars and Swiss watches; pubs are packed with foreigners speaking English with all sorts of accents. A pulsating hybrid of East and West, Shanghai has stepped into the role of showing China the way to becoming a citizen of the world. Two centuries ago, Mr. Fortune predicted Shanghai would overtake Canton as the top financial center in east Asia; Shanghai is now poised to surpass Hong Kong, some experts predict, within a few decades.

But Chen Danyan makes the point that Shanghai's influence on the rest of China is not in displaying samples and trappings of foreign ways; what it is telling China goes beyond the cafés, boutiques, and antique shops. Her city is dramatizing the wisdom of a point of view that has never been overly emphasized here before—that is, not the heroic state, rather the individual.

Chen introduces us to a city of people who carefully create and meticulously preserve a lifestyle they would be hard-pressed to define. It is a characteristic they do not notice until they leave the city, and when they do, they never change their lifestyle. "They never follow the local customs wherever they settle," she writes. "The Shanghaiese think of themselves a bit like Jews. They have a combined Chinese-Western lifestyle that is almost their religion."

Contradictions are the lifeblood of Chen's Shanghai. They ensure that her home will never be allowed to grow dull. Still eccentric at times—never as self-confident and stately as Beijing, nor as broad-minded and lofty as Xi-an, nor as appealing as Hangzhou, as crisp as Guangzhou, or as calm and wise as Chengdu—Shanghai glitters and dazzles, hip and sharp, tuned in and cutting edge—on the surface.

Because at heart, Chen finds, her city still cannot help feeling bad about itself and what it is losing by being swept up in a typhoon of change, advancing into the twenty-first century like a runaway bullet train. "One cannot help but feel the hunger behind all of this vibrancy," Chen Danyan tells us. "It is the need to be one with the world."

Remember the unspoken rule in Shanghai: If someone does not wish to speak, you don't make them. Luckily for us, Chen Danyan has found a way to break that rule—in her own wonderful way.

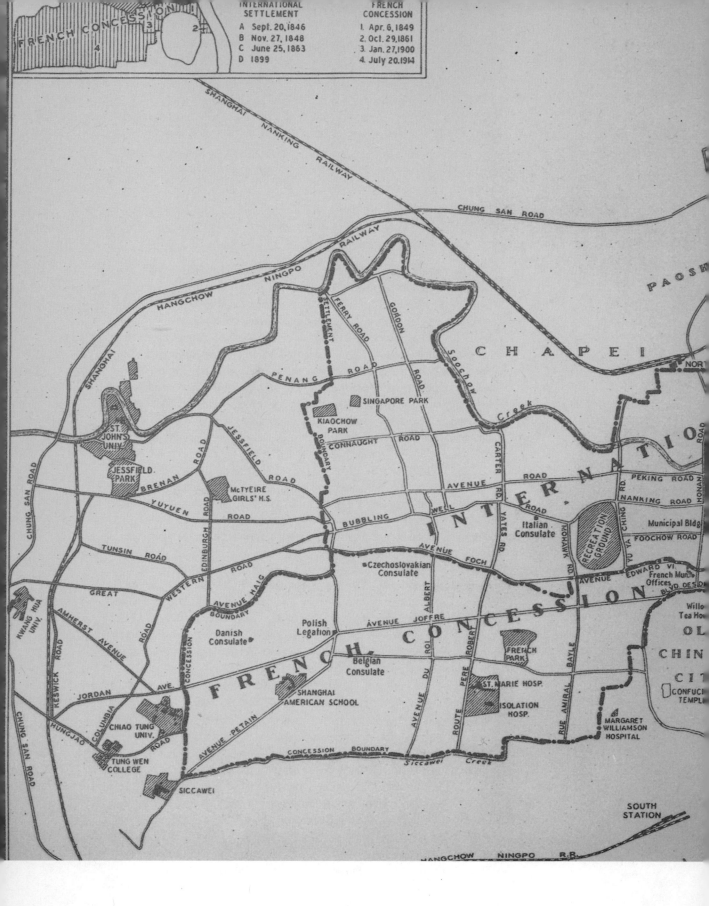

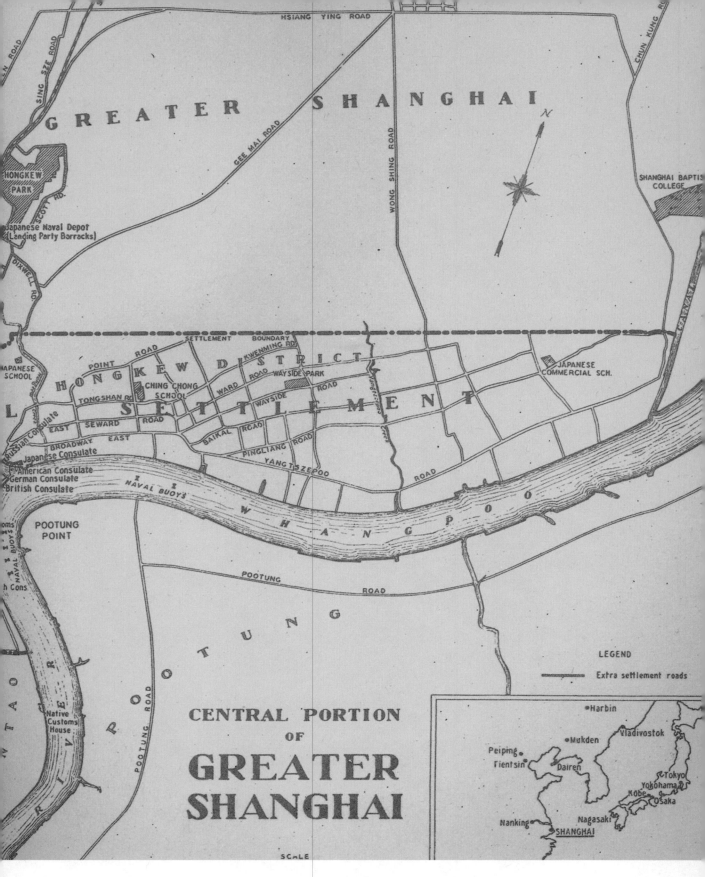

In this map of old Shanghai, the spellings of places are not the same as those used in this book. Pudong, literally east of the Huangpu River, used to be mostly farmland.

When Shanghai walked out of the shadow of ideological fetters in the 1970s and 1980s, it began to recall memories of the old days, making use of simple and crude materials. Then in the 1990s, rapid economic development quickly brought Shanghai back to the scene of a metropolis in the Far East. In the construction of a modern city, marks of the 1970s and 1980s vanished rapidly into thin air.

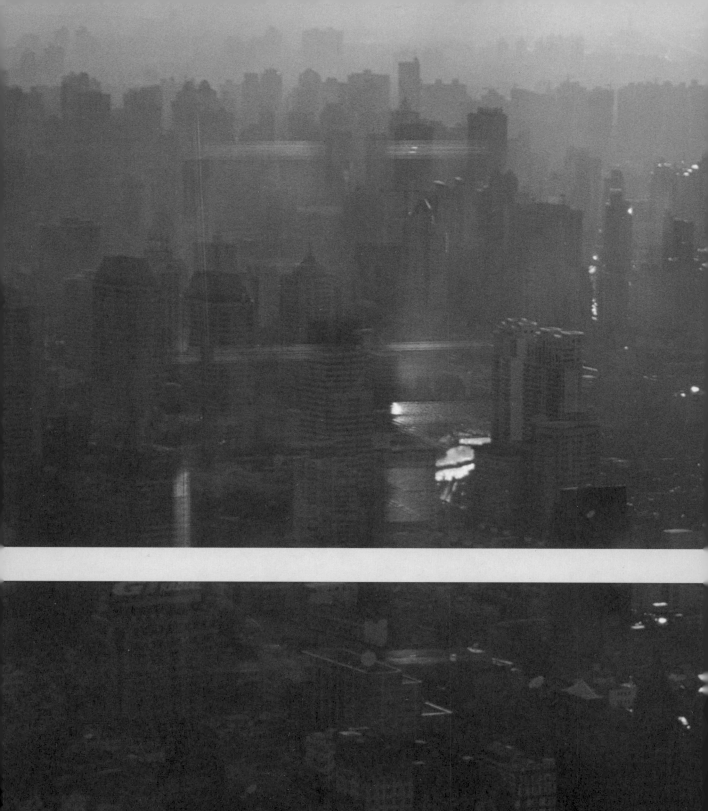
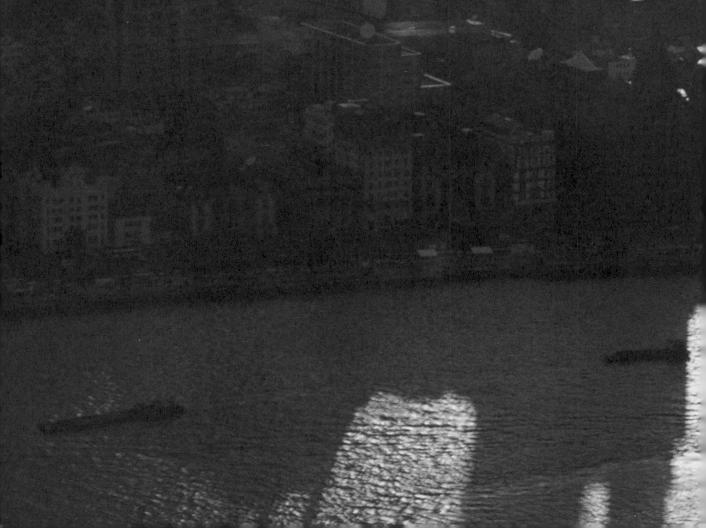

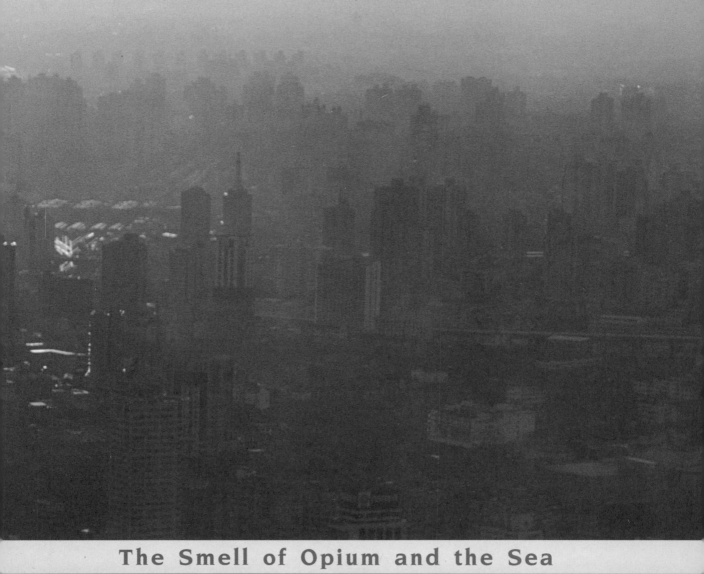

The Smell of Opium and the Sea

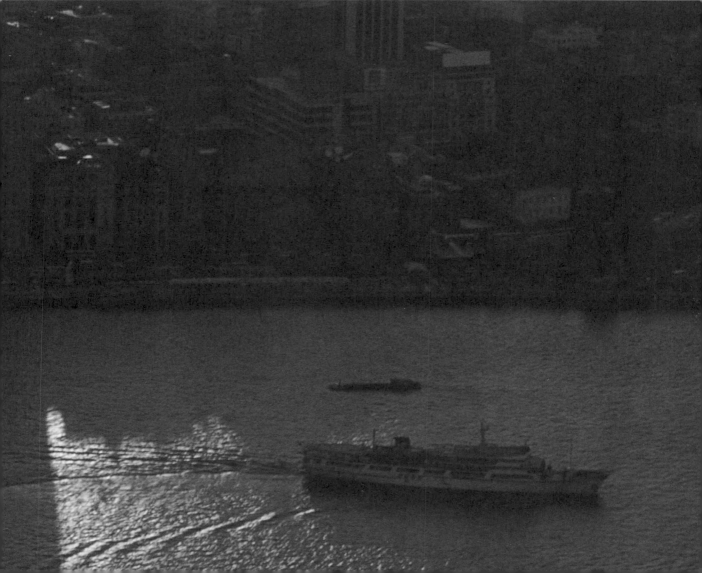

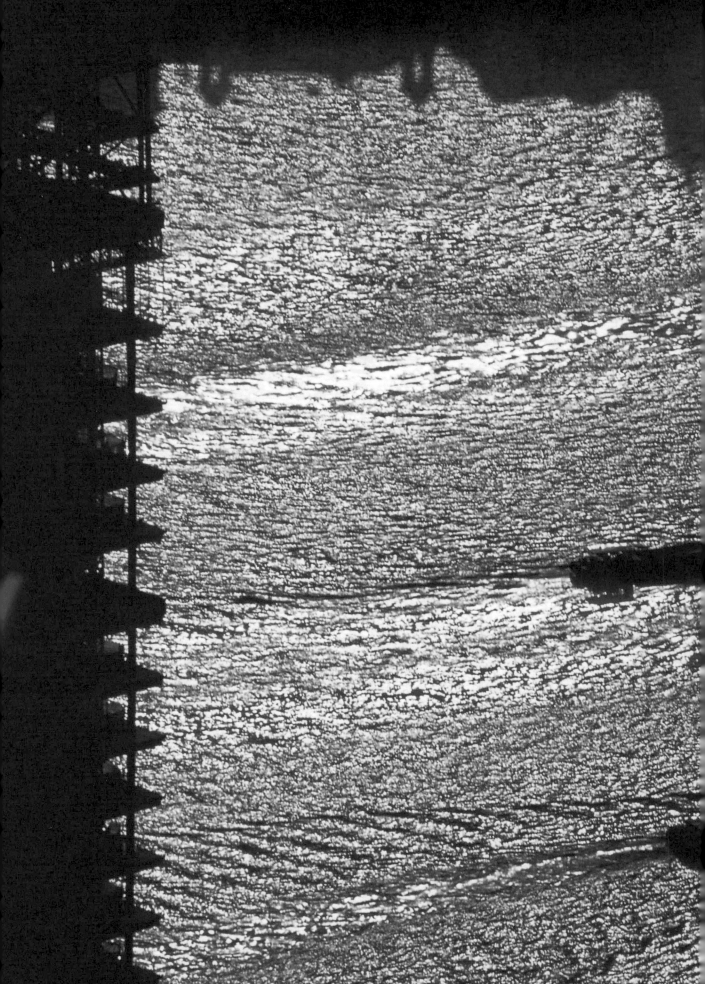

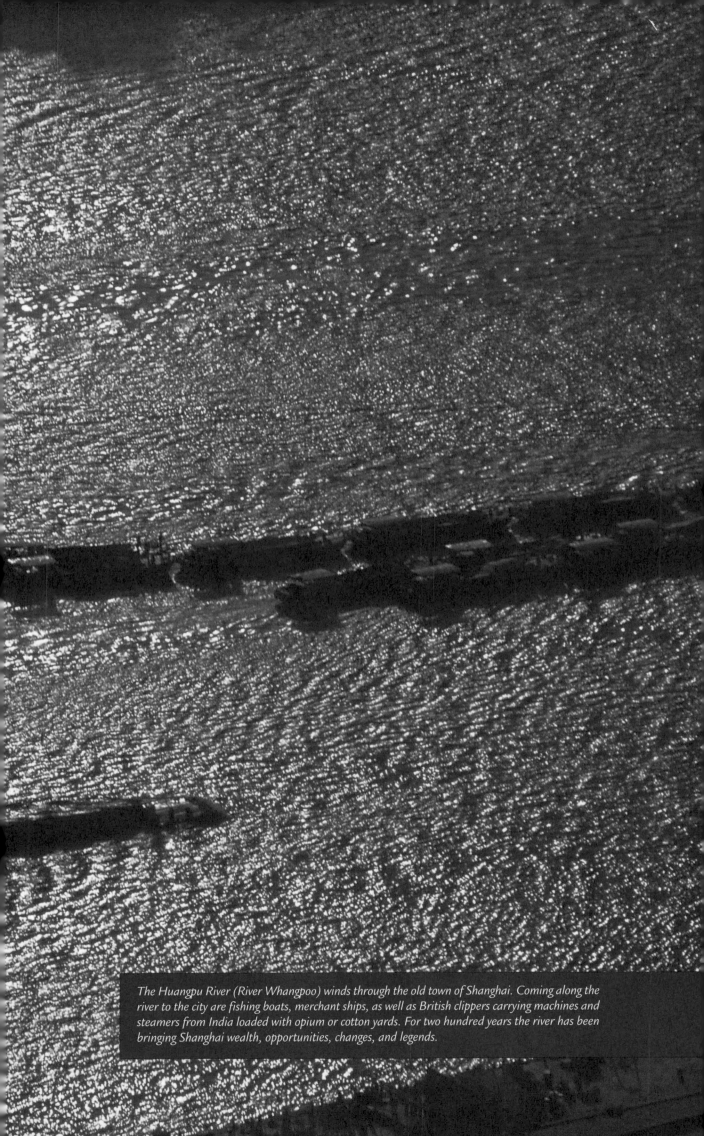

The Huangpu River (River Whangpoo) winds through the old town of Shanghai. Coming along the river to the city are fishing boats, merchant ships, as well as British clippers carrying machines and steamers from India loaded with opium or cotton yards. For two hundred years the river has been bringing Shanghai wealth, opportunities, changes, and legends.

"Do you remember, when we were small, there was a book named *The Tales of Old Shanghai*? It was a collection of stories about the city before 1949. It said that Shanghai at that time was a magnet for adventurers from the West. They arrived in the city with little more than their beat-up luggage and then went on to make fortunes. Many became millionaires."

"That's right," I said, "but these people were driven out by the Chinese after 1949."

"But they are back now," he replied, pointing at Jude's Pub.

But he did not like those foreigners. He complained, "We are doing exactly the same job as they are, but I get a local salary. They have an expatriate package that is three times more than mine. Their compensation doubles when they come to China. These foreigners in Shanghai are making a fortune."

— Jude's Pub

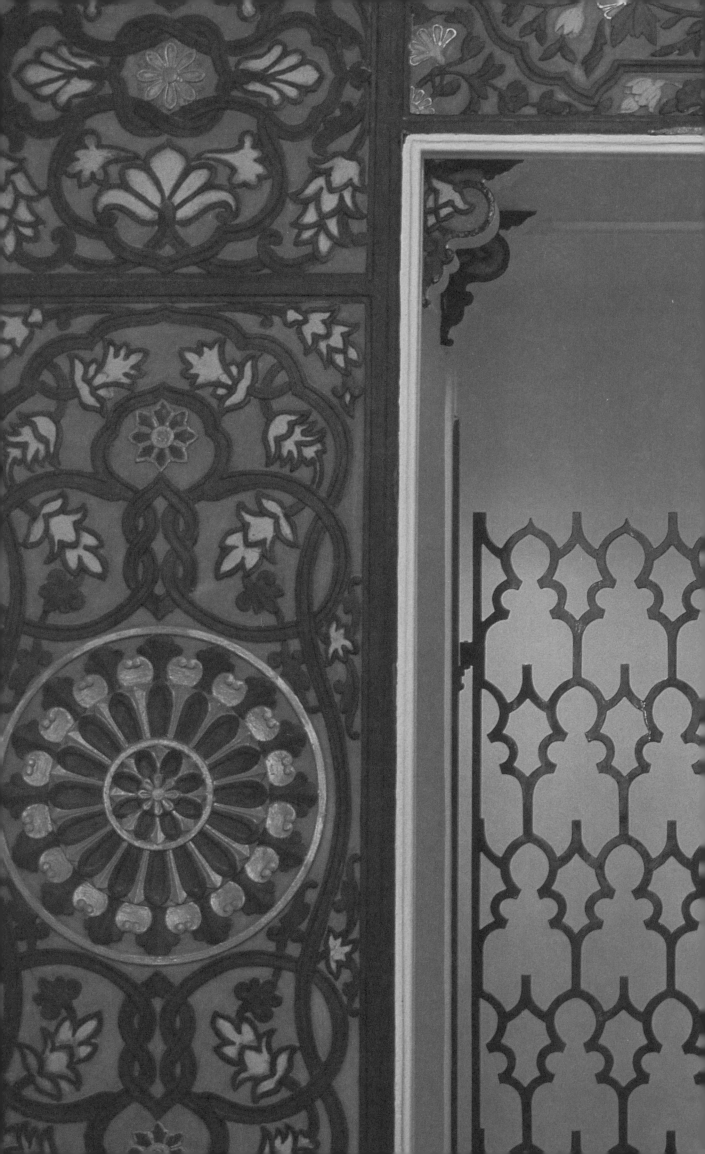

The interior of the Indian Room in the Sassoon Mansion.

On a midsummer night in Shanghai, a warm breeze drifted in the air, like the sound of an accordion in French songs. The summer breeze of this night was just like a noon breeze in the late spring in Shanghai, described by Shi Zhecun half a century ago in his novel *Spring Day*: It was a bit seductive. On that spring day the modest and reserved woman boldly allowed her thoughts to run wild. Shi Zhecun was still young at the time. The Concession was still in Shanghai. He ordered a new French book in the Bie Fa Bookstore, then sprinkled a bit of cologne on his handkerchief. He studied at the Aurora University and wrote Freud-inspired novels in his back room between two flights of stairs. He was ardently pursuing the literary ideal of "whole world come together," inspired in the small café run by White Russians. Those who had that ideal were called the "third kind of persons" by Du Heng, meaning not tolerated in the sky or on the ground.

When I walked toward the Peace Hotel, I couldn't help looking up at the tenth floor. I immediately saw the night sky over the green top of the pyramid. Big pieces of grayish white clouds sighed and floated over the horizon of the Bund. They were sent from the sea by the east wind in the late summer, full of the vapor of the sea. At that time one could smell the humidity in the air of the Bund, the earthy smell of the river and the slightly salty smell of the sea. The smell reminded me of the harbor, and I recalled an old picture in the archives. There was an oceangoing ship with a black painted body and the white rusted rail; gigantic

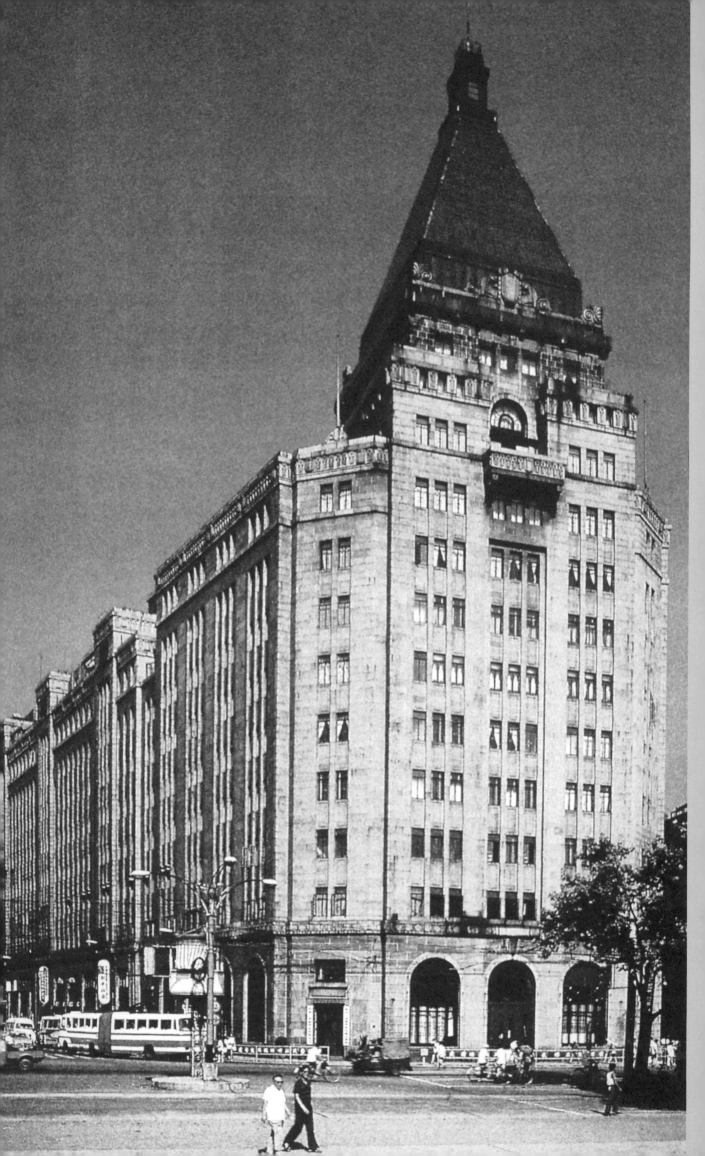

The Peace Hotel in the 1980s, when Shanghai just came back to life. Most people were still living a simple life, and an atmosphere of peace and modesty prevailed over the city.

and strong, tightly bound ropes; and the square grayish white boxes of goods—those would be opium or tea. I had seen it in the old picture in the archives. When Lin Zexu set fire to opium at the Hu Men (Gate of Tiger), of the 20,000 boxes destroyed, 7,000 belonged to David Sassoon. But when the son of David Sassoon took charge, the Sassoon firm surpassed Jardine Matheson & Company, which had been driven out of China by Lin Zexu, to become the number one firm in the opium trade.

Indeed, when it came to it, the Sassoon Mansion, though the most beautiful building on the Bund, did not have a clean origin. Watching the thick smoke coming out of the burning opium, I thought of what my aunt had said—the smoke from the flaming opium had a bewitching smell.

Soon after, I saw the Jardine Matheson & Company building not far away, so sober and solid. The gray, heavy, and oppressive clouds charged above, bringing out the grim, mysterious, and aggressive power of the building. In those days the taipans of Jardine Matheson & Company instigated Britain's role in the Opium War against China. The Bund stood out after that as China fell and broke into pieces.

Each time I came to the Bund, I always imagined I smelled opium and the scent of the sea in the air. In the warm breeze I often thought of the words by Shi Zecun: "Take back the Concessions and regain our spirit."

—The Smell of Opium and the Sea

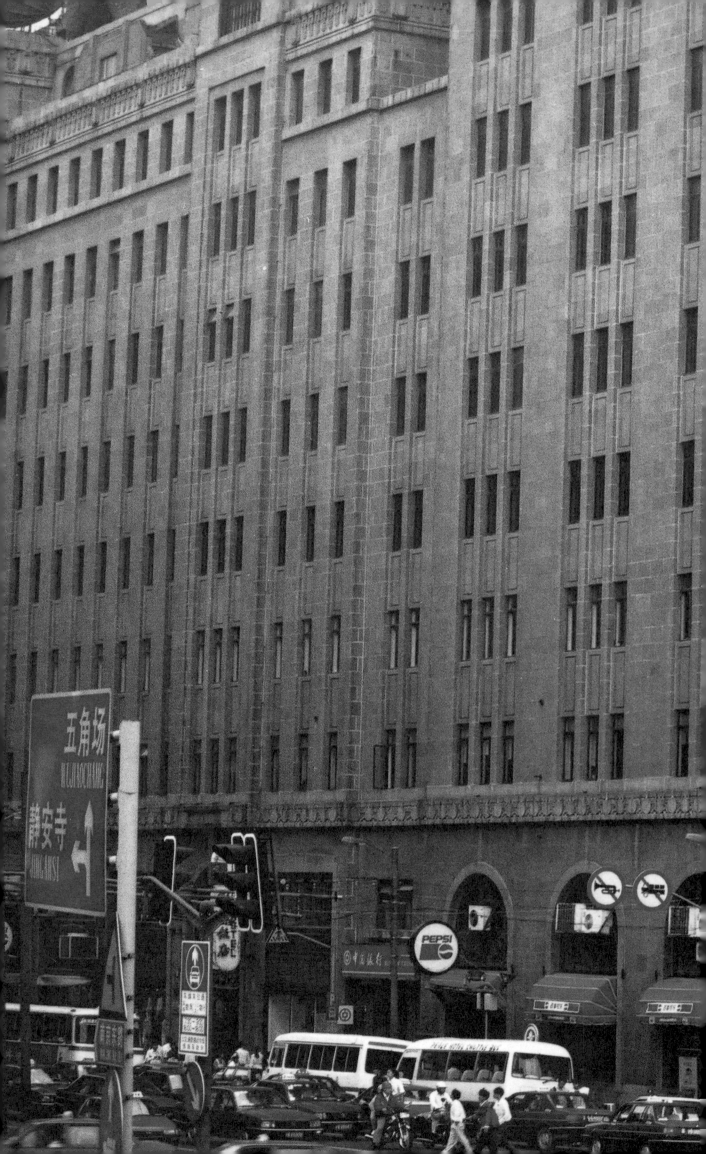

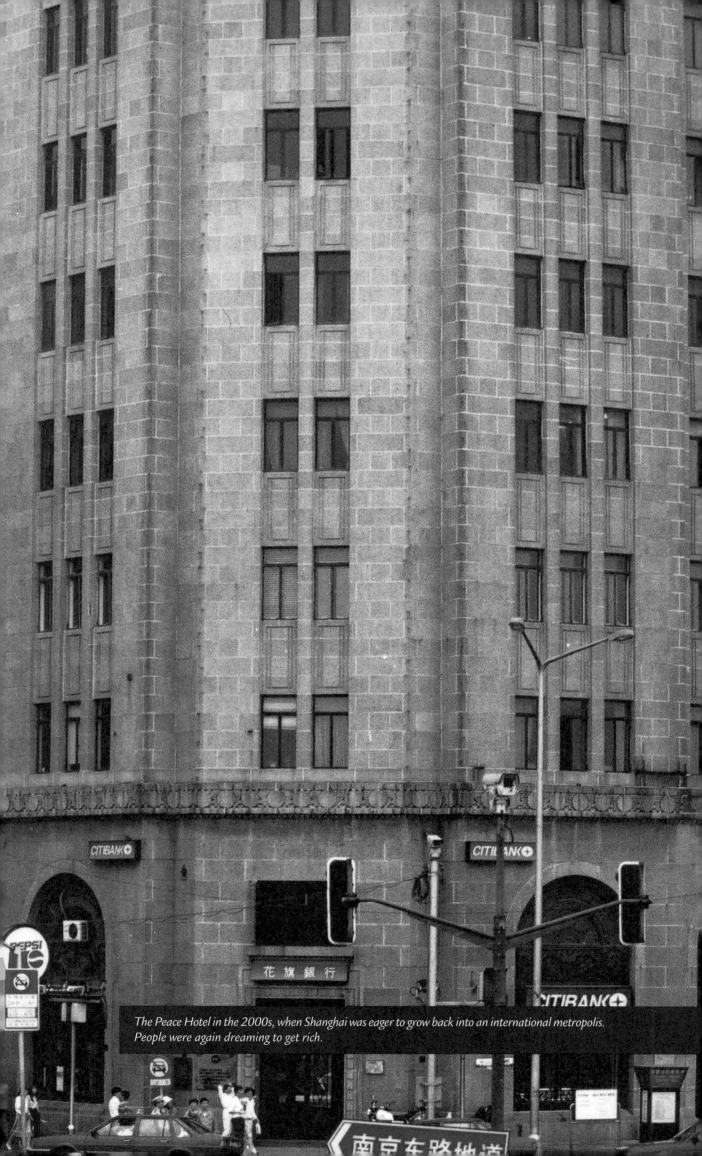

The Peace Hotel in the 2000s, when Shanghai was eager to grow back into an international metropolis. People were again dreaming to get rich.

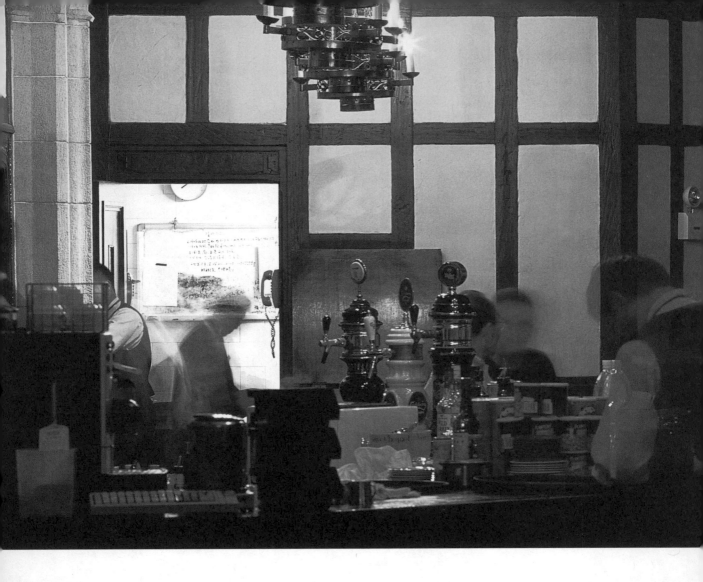

Today there are special lamps to light up the Sassoon
coat of arms with two hounds atop the Peace Hotel. Under
it, bright lights came out from the long, narrow window of the
tenth floor.

After 1929 the room in which Victor Sassoon lived alone for 10 years had
become the small banquet room of the Peace Hotel. Tonight someone
was entertaining in that room. People always say "Sassoon," never
distinguishing between David Sassoon, the great-grandfather, and Victor
Sassoon himself.

There is a Chinese dining table in his bedroom and round
Chinese tables in his living room and study. Sofas block the
fireplace that is embedded in the exquisitely carved panels of
the bookshelves. The wardrobe, which has become a storage
area, is still faintly recognizable as having belonged to a well-
groomed man. Stretches of narrow drawers, of no use today, are
covered with dust. Originally they were specially made for shirts.
The bottom of each drawer was woven from fine rattan, still white
and fresh, as if longing to be used, unlike the rattan chairs that
have been soaked by sweat. The lamp in the wardrobe still works.

One of the rooms has been turned into a bar.

During that visit I couldn't help searching everywhere for things that might have been left by Sassoon: a 1920s-style black bow tie, a silver chain to hang the nose-supported spectacles, a long stocking worn by a British man. Of course, those were just archaeological fantasies.

Victor Sassoon was so cunning and cool-headed that he had not hesitated a moment in his youth to withdraw his assets from Bombay, and when World War II broke out, he left China for Nassau. After the war ended in 1945, the Chinese formally took back the Concession. No matter. He had already made up his mind to leave, as he had done when he left Bombay in the storm of independence. Just like the tides that eventually return to the depth of the sea, in an orderly fashion he followed the colonial map of the East Indian Company, station by station. Everywhere, he left intricately carved houses, wardrobes in which hangers were scattered on the bottom, and tales not fully told. The proud and melancholy faces on the old pictures were like the shells left on the beach, incredibly beautiful or irretrievably damaged.

That day the waiters in the Sassoon Room would be kept busy for a while. When all the guests had left, the waiters had to

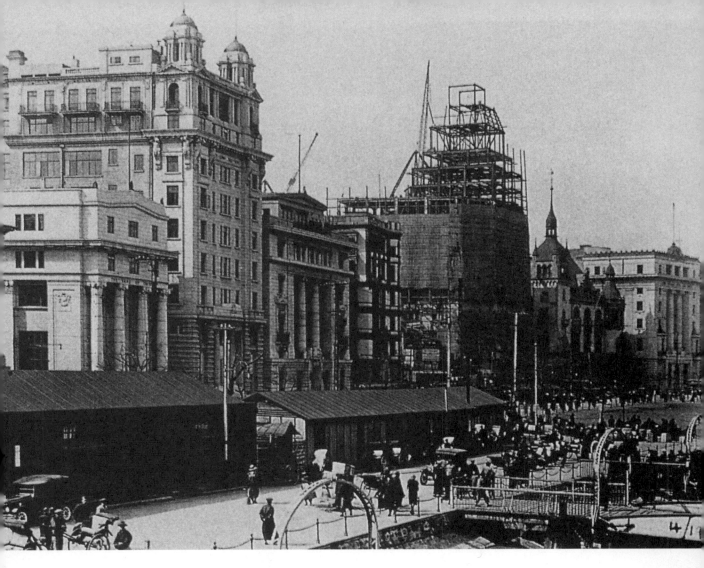

The Sassoon House under construction in 1926. Shanghai, filled with desires and surprises, was turning out to be the most westernized city in Asia. The Sassoon House is now the Peace Hotel (opposite), overlooking the Huangpu River.

clean the room, but they were afraid to be left in the room alone. The room with exquisite dark brown panels often frightened them, so they worked in pairs for the rest of the evening.

I know the fear very well. It is a kind of deep, alienated nervousness, an intense worry about being engulfed, an unsettled feeling around others. People who stay alone in large colonial-era houses often have this kind of fear, and many have strange fantasies. They feel the former owners and sense that the lives of those who lived there before somehow stay there in some way. As the waiters conjure up old scenes of splendor and glory, they visualize old people gazing at them with sad, piercing looks. In these images there is a curiosity about and a fear of the powerful foreign men—a sense of half belief in and half suspicion at the evils and luxuries in the tales. There must also be the implied association of colonialism and insult, shock and fear rooted in the heart from childhood, similar to the idea that a foreigner's camera could suck in your soul. It is angst mixed with all sorts of feelings and as seductive as the forbidden fruit.

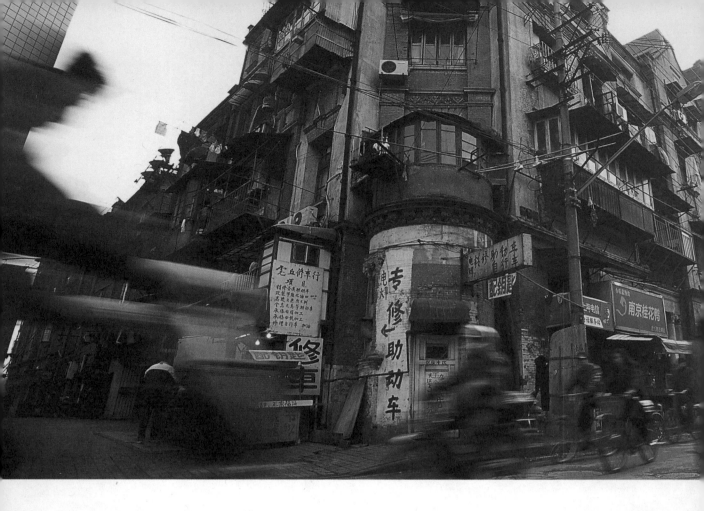

The waiters at the Sassoon Room were very interesting
people. When the rain fell heavily on the Bund and it was all
misty in the room in the afternoon, they gathered in front of the
window of "his" living room and took turns telling ghost stories
while leaning against the exquisitely well-made English-style
teak panels.

> "The golden light pointed to a marble paved passageway. There were
> splendid Victorian curtains hanging here or there. In the air the crisp
> sound of snooker balls hitting one another was heard—hula." Such was
> the impression that a young Jewish girl who took sanctuary in Shanghai
> had of the city: "This big gorgeous house easily reminded one of Vienna."

The young Jewish girl's family was one of the lucky ones.
They had brought out a small portion of their possessions from
Vienna, including a crystal vase left by their ancestors and jewelry
of the Hapsburgs, and came to Shanghai aboard the L.T. ocean
liner. In 1943, when the Japanese drove the Jews who had come
to Shanghai in 1937 to confinement in the Hongkou District,
this family moved to the Sassoon Mansion and hid in a guest
room with a concubine couch near the window.

The Jewish Affairs Office of Japan was right in the building,
in another suite. Inutsuka Daisuke and the Warsaw butcher M
were discussing about how to deal with the Jews. There were

Western-style houses left over from the old days are almost beyond recognition, owing to countless unauthorized extensions. Howerver, one can still vaguely see the Baroque decoration and Roman columns.

three options: One was to put them on a boat, sail it out to sea, and allow it to sink. Another was to force the Jews to work as slaves in a nearby saltern and work them to death. Still another was to build a death camp on the Congming Island and massacre them there.

The girl who hid in the Sassoon Mansion was Annie. Everywhere she looked, golden lights created an elusive dimness that was so much a part of the English style. The lights poured out like fine sand from the black cast-iron-decorated frames of the Viennese Secession style. They shone firmly on the uncertain and strange shadows in the dimness. The lights controlled the clock and made it stop. The lights wiped out space, and people went into a trance. The sinking, gloomy, and quiet golden lights, with the power to hypnotize, made the Jewish girl who had suddenly found herself in Shanghai homesick for Vienna. Later she said that every Jew was always deeply grateful to where he or she had lived as a child. She was confined to the Sassoon Mansion for more than a year. She missed Vienna painfully and sometimes wept in the golden lights, all alone.

Inutsuka Daisuke left. He received an order to go to Nanyang before World War II ended.

The Jewish girl left. After World War II she boarded a ship with her family and left Shanghai. When the ocean liner passed

by the Bund, in the row of gloomy buildings in the dusk, she saw the Sassoon Mansion once more, shaped like the letter A and standing there like a giant ship facing the river. She couldn't quite tell which window was in the room where her family once lived. Standing on the deck with her mother, she and her mother couldn't help crying as they sailed by.

Victor Sassoon left, taking his possessions with him. From then on, his whereabouts were not known on the Bund.

In 1950 the Finance and Economics Committee of the Shanghai Municipal People's Government moved into the Sassoon Mansion and set up their office there. Gu Zhun's office used to be there. Soon he also left and overnight turned from being the most important official dealing with the economy in Shanghai to a counterrevolutionary.

Today, in the long and narrow lobby, the splendid curtain still decorates the door frame and the passageway of the Peace Hotel. The white marble of 1928 has become yellowish and feels as warm and smooth as jade on fingers—the result of the passage of time and the many hotel guests who have touched it. One seems to vaguely hear some crisp sound. However, it is not the sound made by snooker balls striking against one another: It is the sound of the high heels worn by several Japanese guests, who walk by in small steps.

The crystal glass on the door of the ninth floor, crafted by the French glassmaker Lalique, stays in its original place. People

from the Lalique family made a special trip just to view the door. They said that the two pieces of glass are presently worth a quarter of the assets of the hotel. In the Dragon-Phoenix Restaurant the colorful dragon and phoenix relief of 1929 stays on the ceiling. In 1966, when China had a campaign against the "four olds"—old ideas, culture, customs, and habits—the rebel faction of the Peace Hotel covered the ceiling with white newspaper and managed to keep the relief from being damaged. The small octagon table of the Sassoon Mansion is still there, so is the dark green leather chair with a high backrest in the lobby. On the black cast iron, the Sassoon coat of arms with two hounds can also be seen everywhere.

A man with a meticulously pressed khaki Mao suit walked quietly into the hotel. He had a pen in his left breast pocket, copying the cadres who came down to the south. He looked circumspect, humble, and self-effacing as he sat in an old leather round-backed armchair and ordered a pot of coffee brewed from Shanghai Coffee Factory's product. He raised his wrist slightly and picked up the small white porcelain cup in the saucer held by the other hand. Compared with the Viennese coffee of the past, the coffee in his cup was murky and boring. But he did not care that much. His whole body was like a dry, crinkled cotton cloth. When water came in, the body stretched out flat, slightly floating. Finally he relaxed a bit, allowed his stiff back to recline, and sank into the leather chair, which creaked with a light sigh. Those who do not usually drink coffee often can be affected by

This is what one saw in Shanghai in 2001—a strange mixture of elements of different times and different cities. The building at the back is Plaza 66 on Nanjing West Road, Shanghai's busy commercial street. It was developed by a Hong Kong company.

it, just as they might be affected by strong alcohol—their consciousness might feel floating. The man could not imagine that in this place, where there are more red national flags than anywhere downtown, he could be taken back to "the past" in the lights of the Viennese Secession-style wall lamps.

This was the first time that he had come here. In his real past he had drunk the Aquarius salted carbonated drinks and the "Russian" soup made by a Shandong chef. He had studied economics at the Guanghua University. He participated in the antihunger march and went to see American movies at the Grand Cinema. He had his wedding banquet at the Old Shanghai Restaurant. At that time, he did not think of whether he would have a chance to have coffee at the Sassoon Mansion. But now he felt a bit of nostalgic sweetness and sadness, just as he tasted a bit of sourness truly peculiar to coffee, even from this boring cup. The porcelain pot was not carefully wiped, and there was coffee residue on it. But it suited him perfectly.

I have been to the Peninsula Hotel in Hong Kong and the Grosvenor House in Kuala Lumpur. There was a lack of melancholy in Kuala Lumpur and a lack of history in Hong Kong. I also wonder about Bombay. In all the seaside cities touched by the colonists, could it be that the Peace Hotel is the one that has the oldest and the most beautiful lights, ones that are full of feelings?

—The Peace Hotel

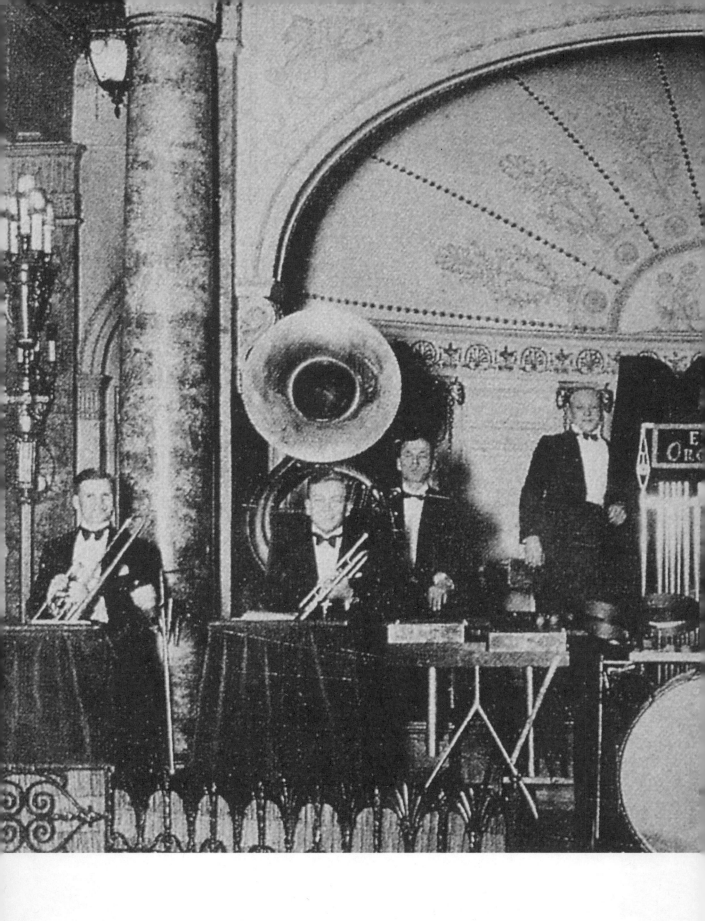

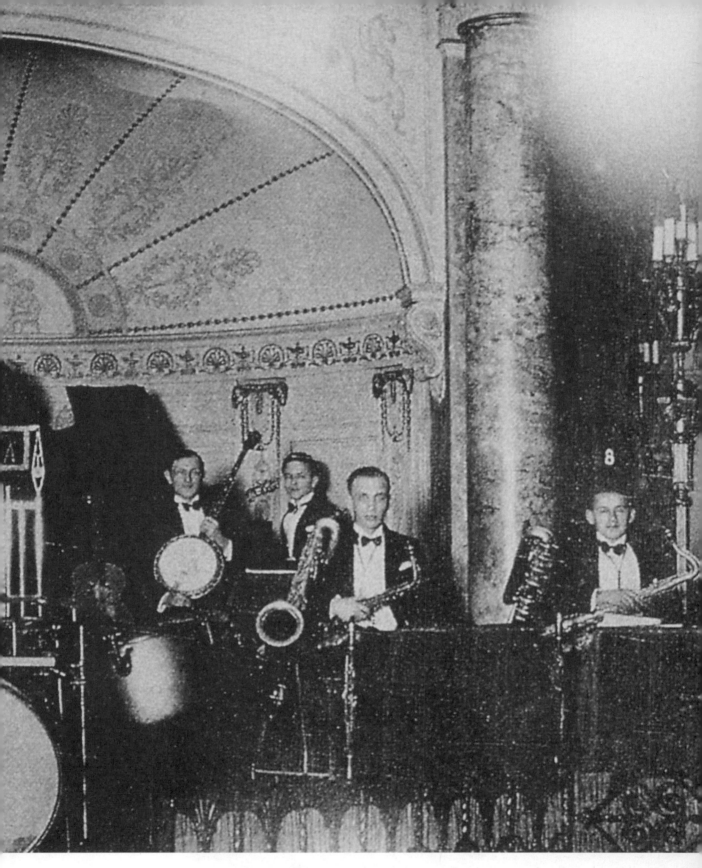

The jazz band of White Russians that performed in the dance hall of the Dahua Hotel in the 1930s — one of the first bands to perform in dance halls and pubs in Shanghai.

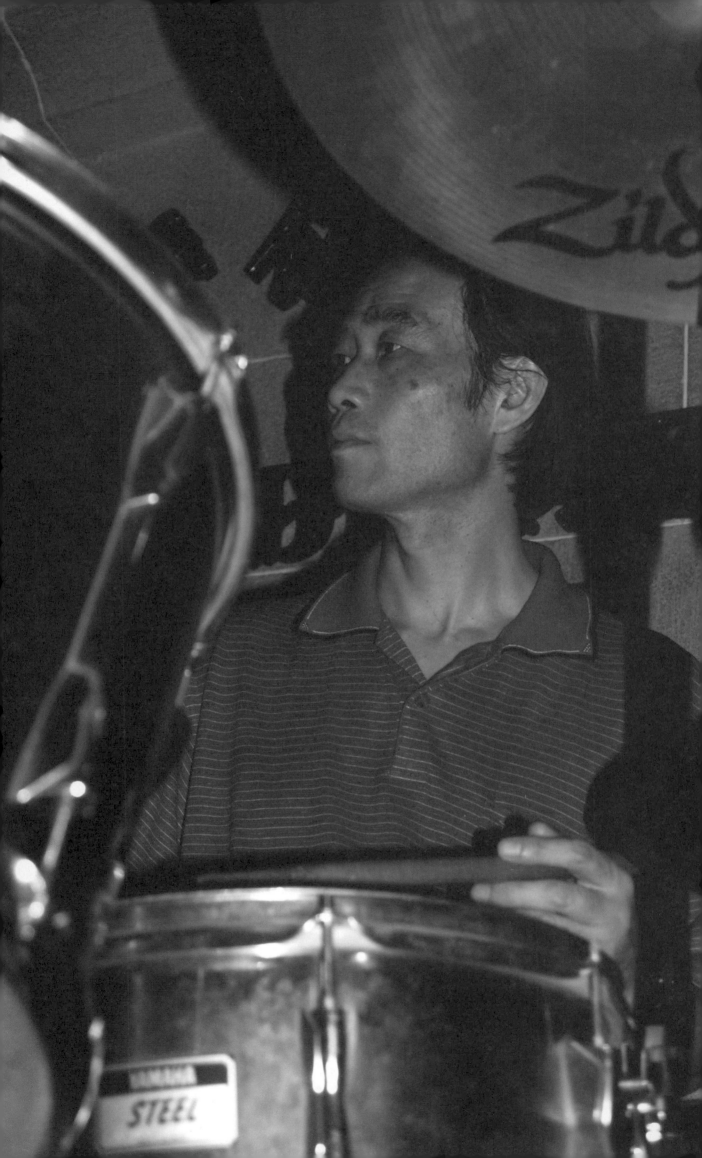

The drummer of the jazz band that performs in the Peace Hotel today.

Before the band started to play here, the Old Jazz Pub on the ground floor was just a boring British country pub, like those European pubs in James Hilton's novel *Random Harvest*. On the bar counter there are overlapping markings left by glasses of whiskey on the rocks and the scratches left by beer glasses. The counter has been used for 24 years, and a thin board covers another counter underneath that had been used for 20 years. The lower one was used between 1929 and 1949, and the current one since 1980. Both are the same dark brown color as the panels in Sassoon's quarters. Countless people have drunk cocktails, beers, and juice here. Occasionally their glasses have left small, insignificant scratches on the surface of the bar.

The dim yellowish lights blink on all sorts of glasses. The atmosphere here is unhurried, the way older people are. The pub is not eager to please; nor does it pretend to be old and respectful. The Peninsula is just like that—actually pretending to be old and respectful is just another way to please. The white shirts of the waiters have not been ironed, and the fabric is rather thin. The waiters assume a most comfortable pose, allowing their chests and waists to fall in a most natural way. However, they do pay a lot of attention to their hairstyle, a strict 3/7 parting: One can tell where the teeth of the comb have passed. The waiters are a combination of the ennui of a 1956 state-run hotel and the residual pride of a luxury Shanghai hotel of 1929. They are not eager to please.

When the manager mixes a cocktail himself, the taste of a Shanghai pub in the 1940s would come through. Master Jin, who

used to work for Jinjiang Hotel, taught the manager his trade in 1980. At that time, the pub was just back in business, and the manager was a 21-year-old ex-serviceman. Twenty-three years have passed, and the manager has gained a great deal of sophistication, but he does not look around in an inviting and attentive way as other bartenders tend to do. The thick dark brown panels divide the yellowish wall. In the glass frame outside the brown door frame, there is a WORLD'S BEST PUB certificate awarded by the American magazine *Newsweek* in 1996.

The Old Jazz Band, which has played in the pub for 24 years, also came from Jinjiang Hotel. The band includes a piano, a trumpet, two saxophones, a bass, a jazz drum set, and six retired men. Just like any other world-famous band, the Old Jazz Band has been interviewed by close to 100 television and radio stations, newspapers, magazines, and countless freelance writers. Presidents, prime ministers, and kings all love to come to the pub to see the performance of the band during their busy visits to China. The trumpeter has thus come to know the faces of the bodyguards who are responsible for the safety of those world leaders. It is the trumpeter who initiated, organized, and leads the band, and he is also its spokesman. When the piano plays the prelude to "A Slow Boat to China," "As Time Goes By," "A Sentimental Trip," or "In a High Spirit," the trumpeter gets familiar with the faces of those Chinese bodyguards interspersed among the lightly rocking and unfamiliar faces of the roomful of important politicians.

The jacket of an old phonograph record by Nelson Eddy.

The whole country was taken with Teresa Teng's soft songs. Copied cassettes of her albums played in Japanese Sanyo recorders all over China.

Suddenly, from the pub on the ground floor of the Sassoon Mansion, came thunderous trumpets and jazz.

The band still wore Mao suits, but one could see the already slackened shoulders and hips of the players suddenly get emotionally charged. The stuffy and loud sound of the trumpet was the jazz of Shanghai in the 1940s, pure and authentic. The jazz of Shanghai had turned from the smoky black music of New Orleans's Bourbon Street to a genteel and polished romance, like the American nylon stocking. The music reflected an ardent desire for worldly pleasures and the unflinching love for America, of a metropolis after the war. The Concessions are gone, but now there is America. On regular nights old men often danced to the music of the band. They would bend their bodies slightly and sway their hips, just like the Americanized youths of the '40s.

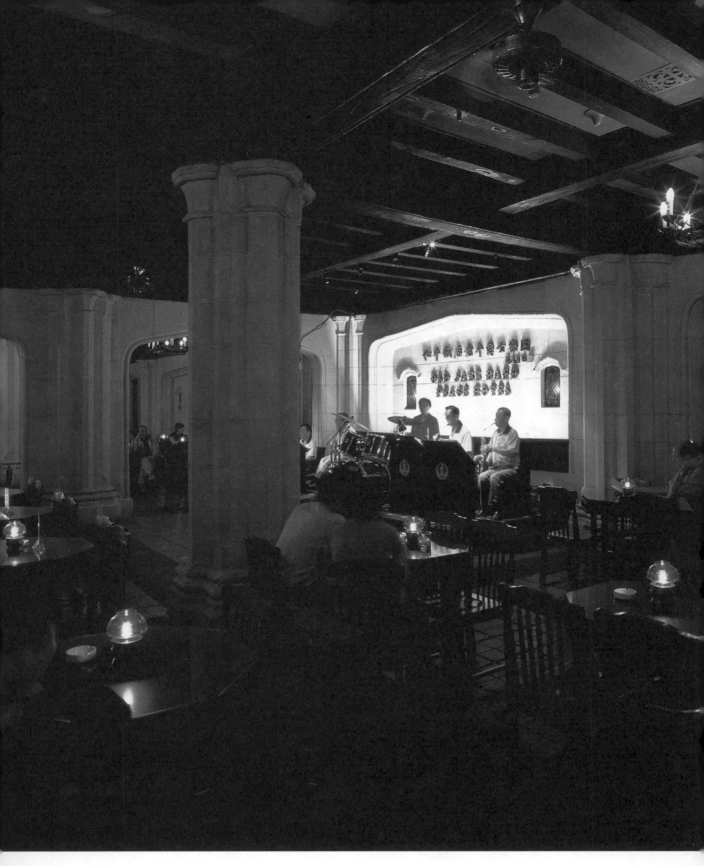

The Old Jazz Band that plays in the Peace Hotel today was the first all-Chinese band formed in the late 1940s. Some of its members are in their eighties now.

When the band first started, the trumpeter and the drummer also felt as if they had returned to the days of the Jimmy King Band at the Paramount. In their twenties they had performed with Jimmy King, and now they were playing together again. The light and upbeat "Waltzing Matilda" played in its original style, brought the Paramount youths together, and bound them in an innocent, flashy, and refreshing way. On those nights in the '80s, they stunned the audience. People leaned toward the octagon tables and listened to them, intent and incredulous, as if watching Alice follow the rabbit, holding a pocket watch, to a different world.

All of a sudden, the band became a symbol of Shanghai.

Around eight o'clock the old men of the jazz band came, one after the other. The dim yellow lights shone on their tidy short hair, the traces of comb teeth clearly visible. They looked just like all the other seniors on the streets of Shanghai. They had been playing here every night for 24 years. "Which band could stay with a pub for twenty-four years, in the whole world? Perhaps there is just us," says the trumpeter. His mouth is extraordinarily soft and wide; I guess that is the result of his profession. The band had tried to leave once, when they had compensation issues. However, they weren't able to find as appreciable an audience outside the pub. They were not comfortable, and they could not adapt. Without the band the pub became an old bore. All at once one smelled the morning-after air of the old house,

the stuffiness of the old carpets, the dried leather of the sofas, and the humid, heavy smell of the paint on the old wood. Ennui set in. Sometimes one felt lonely; other times, sad. The musicians came and went before realizing that the pub and the band were actually inseparable. They needed each other to survive, like fish need water.

It is 8:30 p.m. The players make a long whistle together, perfectly timed and matched. The show starts.

> Sometimes the music is reminiscent of the shining pieces attached to a woman's body, especially when they play "Stardust."

A small middle-aged Japanese man, looking a bit like Haruki Murakami in pictures, sits there, very straight. He holds a big glass of dark Munich beer on his knees and stares at the band suspiciously, as if studying a map. Perhaps his jazz background has some connection with the band, just as the East Indian Company is connected with the band in a roundabout way.

A fat man sings with the music, *The two of us go back to hometown together.* His abrupt voice suggests wildness, as well as a sentimental jazz style. He is a regular, and many old people smile as they sing along with him. The saxophone player even twists his left shoulder in acknowledgment. It is a Chinese country tune played in a jazz style. The man was originally from Nanyang, and when he was young, the Malaysian Communists were in power. It was high fashion among the privileged youths in Nanyang at the time to be sympathetic with the Malaysian

Communists, but he was exiled forever from his hometown. It is said that some of those young people have been growing sugarcane and pineapple ever since, in the fields of Hainan Island. Many of them became attached to the tunes of China's countryside, just as Chinese youths of the time looked to Russian songs for their musical inspiration.

People sit here in the hot night just for the chance to remember. The fat man's song is like the thin lid on a milk pot when the milk is boiling. The lid makes an abrupt sound. The man's song echoes everyone's curiosity and sense of expectation.

"When a person at seventy or eighty years old hears the songs he heard at twenty, how do you think he feels?" the trumpeter asks. How about himself, then? From twenty to eighty, playing the same music in the same place—how many couples has he seen dancing to his music? How many people have passed away? How many couples have broken up? How much sorrow and joy, separation and reunion?

Memory needs to be revisited in the right atmosphere, of the pub. There is an edginess in the air, like the scream that erupts when a trumpet breaks through the sound of the

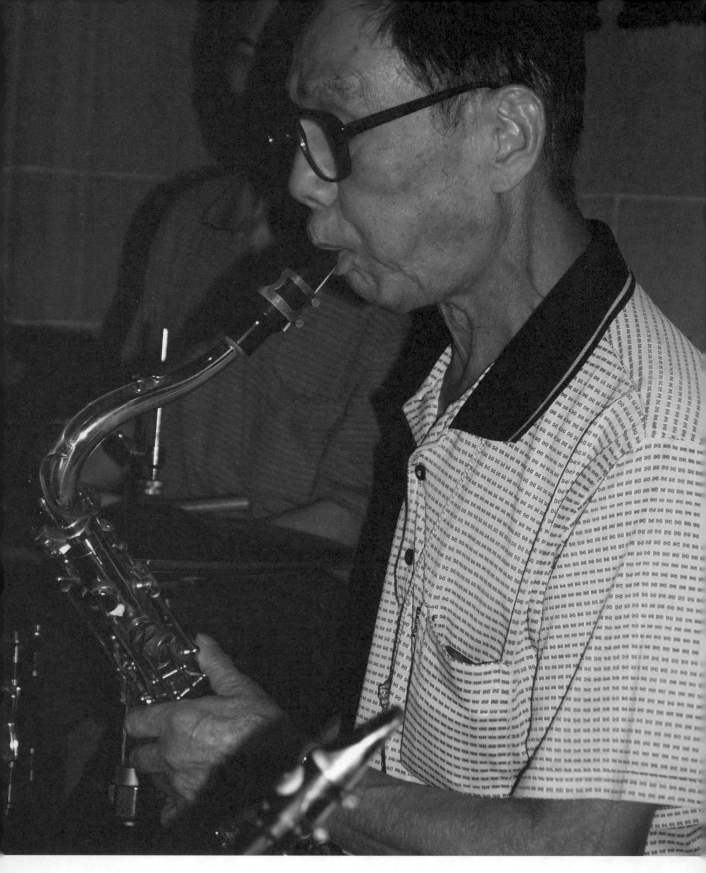

One of the players of the Old Jazz Band.

trumpet, piercing into the shameful corner of our hearts covered
by past events. The young people look lost. When "My Heart
Belongs to Papa" is finished on a long, flowery, complex note,
an elderly American lady rushes to the band, her face tear-
stained. She had heard the song in high school but has not heard
it since. A man looking like a German businessman put 30 yuan
in a note and requests "Waltzing Matilda." As the music plays,

he closes his eyes tightly. Was it a pop song from his high school days?

My friend hums along, rocking his head. "My father sings that song often at home. It will have a hushed sound." He strikes the note with his forefinger, and the trumpet indeed makes a hushed note there, using a piece of rubber as a mute. "I do not know the name of the song, but my father often hums it at home." He thinks back to the 1970s; his father was an old man who had experienced much hardship. His first wife, Huang Zongying, labored in a cadre school. His second wife, Shangguan Yunzhu, committed suicide. His third wife, Wu Yan, labored in the neighborhood under supervision after having served a jail sentence. It was a happy day for them when they could buy the uppermost part of a pork leg.

The music is so engaging, with a bit of cunningness and sense of melancholy, that both dim and crystal-clear memories arise in all flavors and colors. The golden lights of the pub make it seem like a dreamland, where Japanese, Nanyang people, Germans, Americans, French, and Vietnamese all are welcome. The music appeals to everyone because of its diversity. It inspires sentimental memories that win respect in the late-night atmosphere of the pub.

The music is indeed one of the symbols of Shanghai, and the night goes deep.

—The Old Jazz Band

The Huangpu River seen from the windows of a café near the Bund.

After 1840 foreigners brought Christianity, opium, machine technology, Western architecture, inland and maritime customs and procedures, and cafés that opened hesitantly on the ground floors of the buildings on the small roads near the dock on the Bund. Initially, the narrow, dim Shanghai cafés must have been opened just for those homesick foreigners and for seamen from foreign cargo ships so they could have a shot of steamy, aromatic coffee and a place to relax in the sultry East. At first the owners of the cafés were foreigners. People who frequented the cafés near the Bund were all foreign men, and the prostitutes near the dock—the Shanghaiese called them "saltwater girls"—were foreign as well. After that came those Chinese who were associated with foreigners or had business relations with foreigners—the Shanghaiese called them "compradors" or "intermediaries." Soon people and affairs associated with foreigners began to take place at the cafés. As the popularity of cafés grew, the ground floors in the hotels serving foreigners all had an area for coffee and alcohol.

However, neither the café operators nor the coffee itself anticipated the humidity of the southern Yangtze regions. A German missionary recalled in his memoir that when he drank coffee in Shanghai, it struck him as too sour. "They must have kept the coffee for too long, and the coffee must have got damp," he reasoned. However, those compradors who accompanied foreigners to cafés did not have any point of reference, and they spread the word that coffee was like "cough syrup."

Reflections of the Huangpu River and the financial district by the river.

When Shanghai became a truly big city, cafés were seen everywhere, on avenues as well as in small alleys. Fashionably dressed youths frequented these venues. Qinling and Meiling, sisters of the Song family, often went to cafés in the French Concession for cakes—that was before they broke off relations on political grounds. (Song Qinling was the wife of Sun Yat-sen; Song Meiling, the wife of Chang Kai-shek.) Shi Zhecun, the pioneer of modernism in his day, his good friend Dai Wangshu, and Shao Xunmei from Aurora University would go to a café after they had been to the bookstore on the Bund and had bought some newly arrived French books. At that time Shi Zhecun learned to smoke cigars, and he has kept the habit to this day.

The Communist Zhou Yang also frequented cafés, wearing a white suit—the fashion of the time—to conspire on the activities of the left-wing cultural circle. Also, fashionable people sat next to big glass windows and ordered cups of coffee. Coffee was always served with two cookies laid across on the saucer or with a small plate of cream cake.

People say that the Shanghaiese are smart people who quickly learn from innovators. The first cafés may have been opened by foreigners, but as the Chinese joined those cafés as waiters, managers, and pastry makers, they began to open up cafés themselves. They, in turn, hired foreigners to be the waiters, managers, and pastry makers. Their cafés were authentic, sometimes better than those managed by foreigners themselves. During the Pacific War the sea blockade did not interrupt the cafés' coffee supply in Shanghai, for at that time Yunnan started to produce high-grade coffee beans, which could also brew coffee of the right acidity and aroma.

Steamy, aromatic coffee was served, with milk and sugar, to customers in high-backed seats modeled after train seats, the fashion of the time. Cafés became very prosperous and formed part of the scenery of Shanghai. People went to Beijing to see the Great Wall and the Forbidden City, went to Hangzhou to visit the West Lake and Lingyin Temple, and when they came to Shanghai, they had to see the cafés and drink a cup of "cough syrup."

This picture was drawn by the author, Chen Danyan, while she was drinking coffeee in a café.

Later, Avenue Joffre of the 1930s became Lin Sen (Middle) Road of 1945 and then Huaihai Middle Road of 1952. Café owners on the street all submitted applications to operate restaurants instead. One reason was that the American fleet's blockade lessened the supply of ingredients with each passing day. Another was that the high fashion of the time was plain country style. Killing time in a café was seen as an extravagance. The attraction was no longer there; there were fewer and fewer customers in the cafés.

As a result, on Huaihai Middle Road many cafés turned into breakfast eateries. From the former train seats arose the aroma of small, steamy wontons. The small white plates used to serve coffee found a new use—to serve meat buns and vegetable-and-mushroom buns. Sometimes the meat bun was too fatty, and one had to eat it with vinegar. When one poured rice vinegar onto the plate, one could see scratches caused by the bottom of coffee cups. When I was small, I often had breakfast in those eateries and I became accustomed to them. Later, in newly opened restaurants with square tables and square stools, and

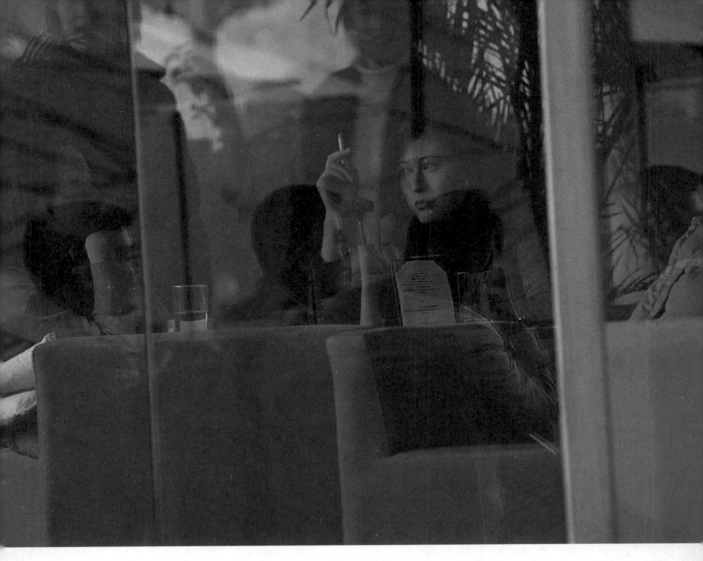

Nowadays there are numerous cafés in the streets and alleys of Shanghai. For some women, having a cup of coffee in a café is an experience not to be treated lightly.

with other guests walking behind my back, I felt rather uncomfortable.

Everyone thought Shanghai's cafés were gone forever. However, 30 years later, they came back to the avenues and alleys of the city. It is said that the first café was at the intersection of Baoqing Road and Hengshan Road. With the door closed, the place looked like a normal, quiet residence. However, there was a small neon sign announcing COFFEE.

Thirty years later, fashionable people of the new generation did not really know how to drink coffee. They did not know that you needed to take the small spoon out of the cup and place it on the plate before drinking. The new café managers did not really know how to brew coffee either: They tended to use instant Nescafé to serve their customers casually. In the 1980s there were no coffee brewers in cafés, and cakes were bought from the Harbin Food Factory. Sometimes the cream was not fresh enough, and when one cut a cream cake with a knife, a big piece would crumble apart. Still, nothing could prevent the rebirth of cafés in Shanghai. After 10 years, in 1990, all types of coffee

could be ordered from a menu: blue mountain, mocha, Irish coffee, Japanese iced coffee, Italian cappuccino, ordinary American coffee. There were all styles of cafés, as well: nostalgic ones, modern ones, anything. Waiters knew how to do the right motions on the counter—they'd shake the containers properly, looking professional. In good cafés homemade cheesecakes and muffins were served. And when they came out of the oven, the aroma filled the shop. The waiters were trendy. They even used blue contact lenses to look blue-eyed.

If there is any difference between cafés in Shanghai and Europe, it is that there is a lack of casualness in Shanghai's cafés. Here people make a point of being carefully dressed and well turned out. No one just drops into the shop. After all, visits to cafés in Shanghai are more of an "occasion," a fashionable occasion associated with foreigners.

—A Chronicle of Shanghai's Cafés

Renovated Shanghai lanes in xin tian di (New Heaven and Earth) develop into a favorite destination with their classy cafés, bars, and restaurants. Cafés in Shanghai seem more or less associated with fashion. People go there to get away from routine work and enjoy a quiet (sometimes not so quiet) moment.

Buildings of old and new, lifestyles of old and new, all mixed up — this is what you see everywhere in Shanghai. This is a sophisticated city, full of contradictions, and therefore never boring.

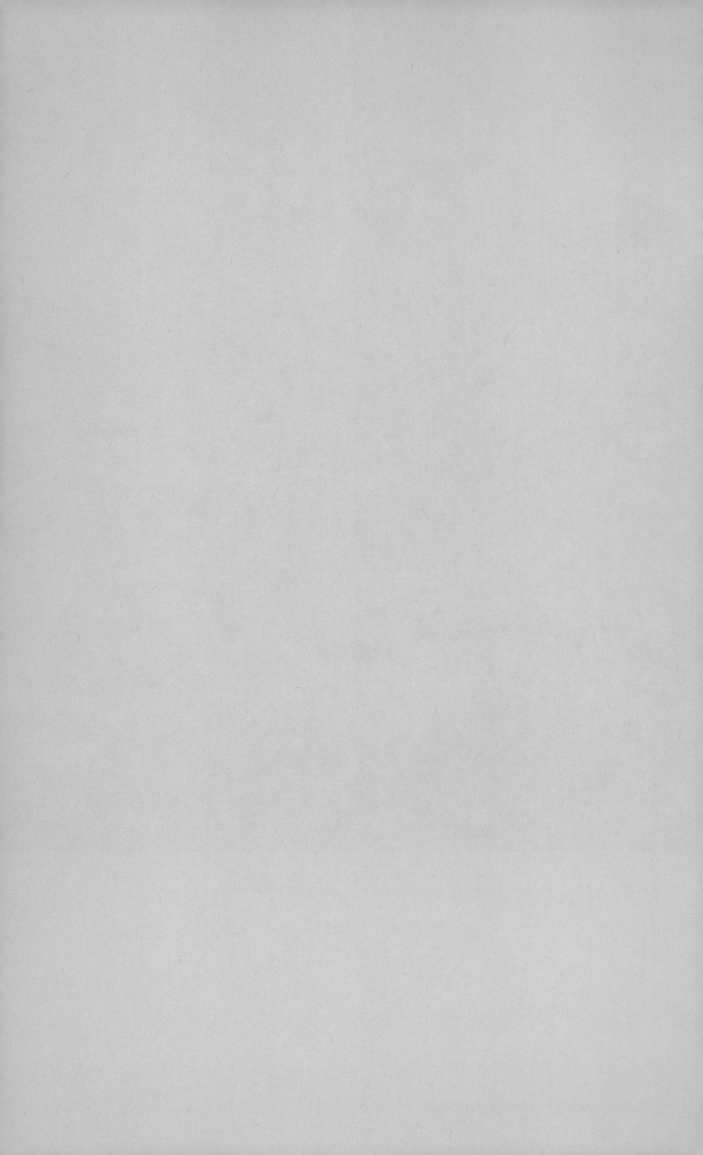

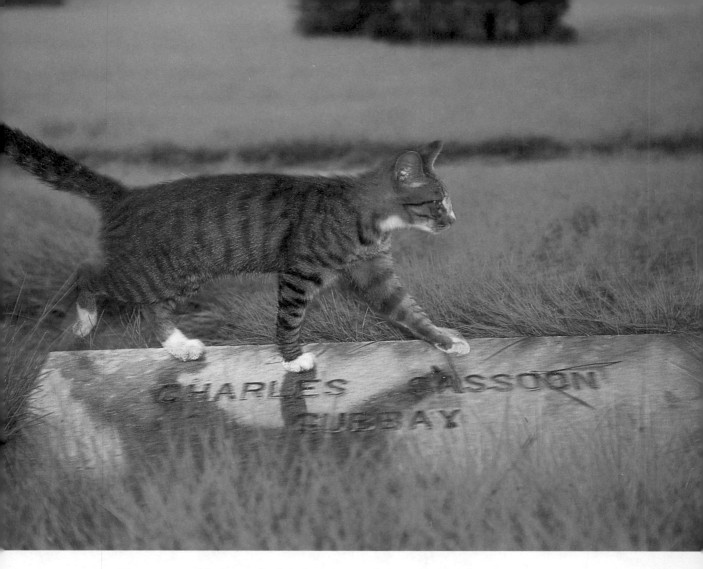

The gravestone of the Sassoon family in the International Cemetery in Shanghai.

When I used all my might to pull the tendriled vines away from the ilexes, the silence of the cemetery was broken by the sound of the cracking vines. That time I spotted two Jewish cemeteries. One was for the Sassoon family, who built the most luxurious hotel of the twentieth century in the Far East on the Bund. The most important people in Shanghai of that time had all lived there, where the corridor was covered with red carpet. The other was for Kadoorie; his family built the most famous marble mansion during World War II in Shanghai—the Marble Palace. After 1949 it became the Shanghai Children's Palace; hordes of Shanghai kids wearing red scarves came here for activities. They found traces of a splendid and beautiful life left in the palace, and their curiosity about that kind of life and the people of that time was aroused. I was one of those kids.

I went to pull out weeds from the stones of some of those people, removing years of withered leaves to allow names to appear. Many names were not in English; I could guess some in German, French, and Japanese. Other names were in languages I did not know. This was the International Cemetery. Bodies of

Bodies of the foreigners who died in the past 200 years were buried in the International Cemetery in Shanghai.

the foreigners buried all over the country were relocated here. Many did not have a long life. Was it because Shanghai was too humid and hot, and people from the North easily got sick? I wondered. Then I lay down on the grass.

In the quiet I saw cotton clouds of spring, alight with bluish vapor, drifting over lightly. Behind the clouds was the humid blue sky. When those foreigners who were buried in the cemetery were still alive, were they also walking under the same cotton clouds and blue sky? How did they come to Shanghai? Did they ever bully the Shanghaiese, or did they fall in love with the place? Did they come here to make a living, for an ideal, to escape something, or were they simply sold to a cargo ship headed for Shanghai, not of their free will, but were they "shanghaied"? No matter what, these people who died away from home made Shanghai what it was, and they are forever part of the history of the city.

I think it was from that day on that I realized that I loved the cemetery, and because of that realization, I have since met people

with similar sentiments, people who loved to think in the quiet of the cemetery.

A few years later in springtime, I took a friend who was visiting from Germany for a walk in the International Cemetery. The grand cypresses on either side of the road had grown really tall, giving out a pungent smell of rosin. I showed her those tombstones, which still had a special posture, peculiar to tombstones standing in a corner of a faraway land that was not home.

They were covered with ivy, but the layers were not getting thicker. It seemed that although the owners of the tombs were no longer known, they were still being cared for by the cemetery. That day there was a turtledove singing in the sky or high in the trees; it must be lost, I thought.

We pulled away the weeds, small flowers, and vines to visit those lonely tombstones. This time I saw that they were all made of the same stone, used the same font, and were the same size. It was as if they were made in a bulk order. Then my friend found some German and Latin names on the tombstones. She walked

In the 1950s, foreigners left Shanghai one after another. With the economic takeoff in 1992, foreign enterprises began to enter Shanghai again, and so did a new generation of foreigners. The seats in this hall were neatly lined up for yet another business presentation.

over and pointed to one of them and said, "The accent is missing here."

I realized then that the tombs had been relocated here and were all given new uniform tombstones. That was why in this cemetery, people who had died at different times, were from different countries, and were buried in different places, now had the same tombstone. Perhaps the city administration people who were responsible for the move paid for the new tombstones and arranged to make them all the same. At that time almost all the foreigners were already gone. More likely, those people who had died earlier did not have relatives or friends in Shanghai when their names were inscribed on the new tombstones, so they would spend eternity under a tombstone that did not speak German or Latin. But it was also quite possible that a person with a German name had used a Latin spelling in Shanghai. He may have removed the accents himself so that people around him would find it easier to remember and pronounce his name. It was just like the Chinese living abroad—they often had a foreign name that others could remember and speak easily. These things that may have happened many years ago are to be found only in the imagination and speculation of people today.

——Hongqiao International Cemetery

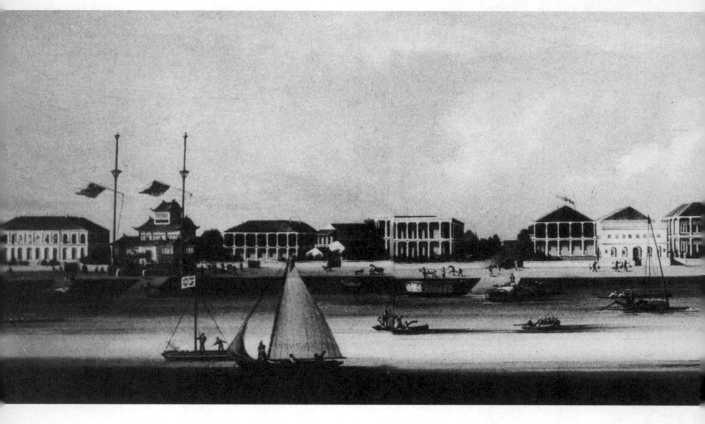

An artist's creation of the Bund in 1849. The narrow strip of water in front of the British Consulate on the right end of the picture was later turned into a park.

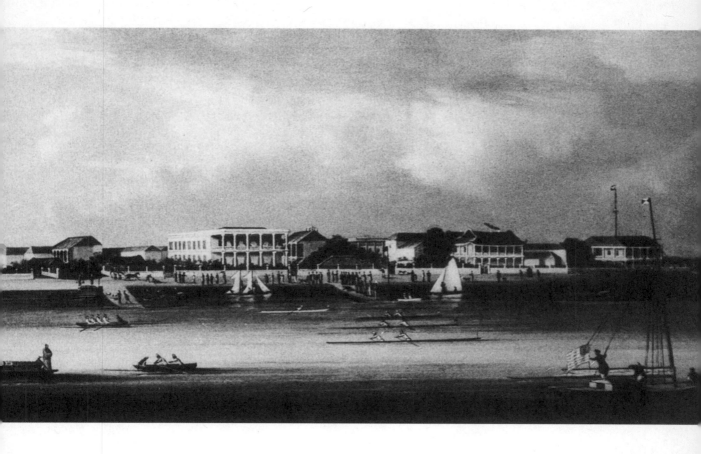

On November 17, 1843, the Shanghai Administration allocated to the British a waterfront village and the nearby old farmers' cemetery. The British were regarded by the local Chinese as "foreign devils," so perhaps it was appropriate that they live with true devils (the ghosts). The foreigners were not allowed into the Chinese quarters, though they had no wish whatsoever to join the locals. When they were in India, the British usually lived near the river, where they docked their boats. The riverfront was called the "Bund." The Bombay people were the first to call it that; the marine doctor with Jardine Matheson & Company also called it the Bund. Later the world came to call Shanghai's waterfront the Bund.

During the 20 years between 1840 and 1860, two- and three-story colonial-style buildings, with tropical-style porticos, were built all along the Bund. This kind of construction was most popular for residences in hot areas, such as India and Nanyang. One day a large wooden boat sank in the shallow water at the intersection of the Suzhou Creek and Huangpu River. The Bund was often used for the opium trade, and people imagined it was a barge with a full load of opium. The heavy boat turned upside-

(continued on page 68)

What fantasies are going up with the kite in the sky?

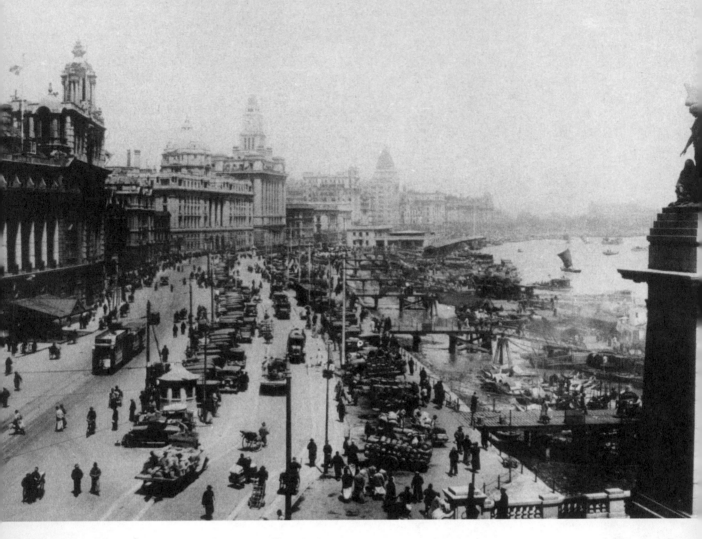

The Bund already bustled with traffic in the 1930s.

down very close to the surface and blocked the movement of the mud and sand in the shallow water. Gradually the mud and sand accumulated and formed a small island.

> Reeds grew on the piece of land and vibrated in the wind. The view from the balcony of the British consulate was all greenery and innocence, reflecting the joy of the wilderness and British-style gardening. It was a lovely, petit peninsula, facing the water on two fronts.

In 1862 the Shanghai Expatriate Affairs Foundation planned to create a park on this land. They were convinced that foreigners living in Shanghai were yearning for a park like those seen everywhere in Europe. Except for the private gardens in the luxury residences of the taipans and diplomats, there were no public parks in China.

In 1865 Vincent, the new British consulate-general, formally proposed to the Shanghai Administration the conditions for building a park on the muddy land that belonged to the Chinese Administration. He suggested that the Shanghai Municipal Council (the administration in the Concession) fund a project

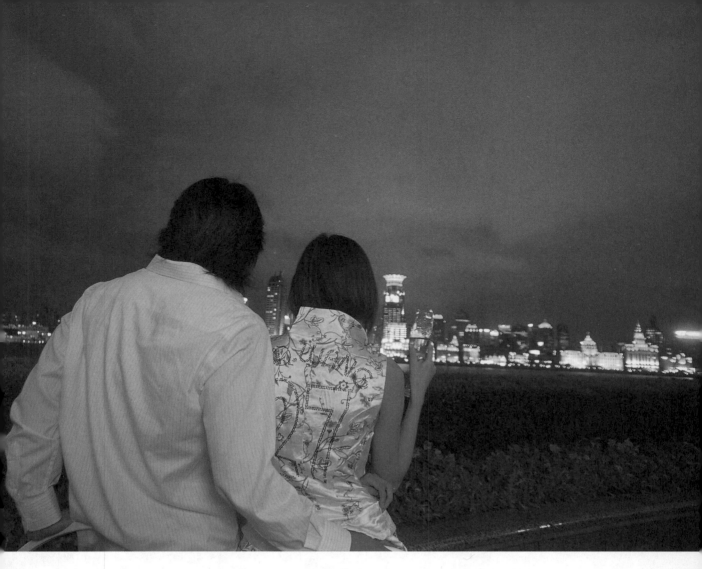

The 21st-century Bund, where people can enjoy the view of both the old and new Shanghai .

to dredge the shallow Suzhou Creek to ensure the flow of the waterway; in exchange, the Shanghai Administration would allow the council to use the sludge from the dredging as landfill for a piece of muddy land along the bank, which could then be turned into a public park. The administration agreed, and three years later the piece of land near the Garden Bridge was the site of a 30.473-mu (approximately 20,000 square meters) public park.

At the entrance to the park, there was a wooden sign stating the detailed rules of the Park on the Bund: Cyclists were not permitted; neither were dogs, nor the improperly dressed. Chinese were not allowed to enter unless accompanied by Westerners. At that time, only Chinese maids working for the Westerners ever entered the park—and that was to take their masters' children out for some fresh air. (Foreigners were always keen about their lungs.)

The Chinese people really didn't know what the word "public" meant; nor were they clear whether it had anything to do with them. During the War of the Muddy City, when the foreign men took their girlfriends for a walk in the Chinese quarter, the two

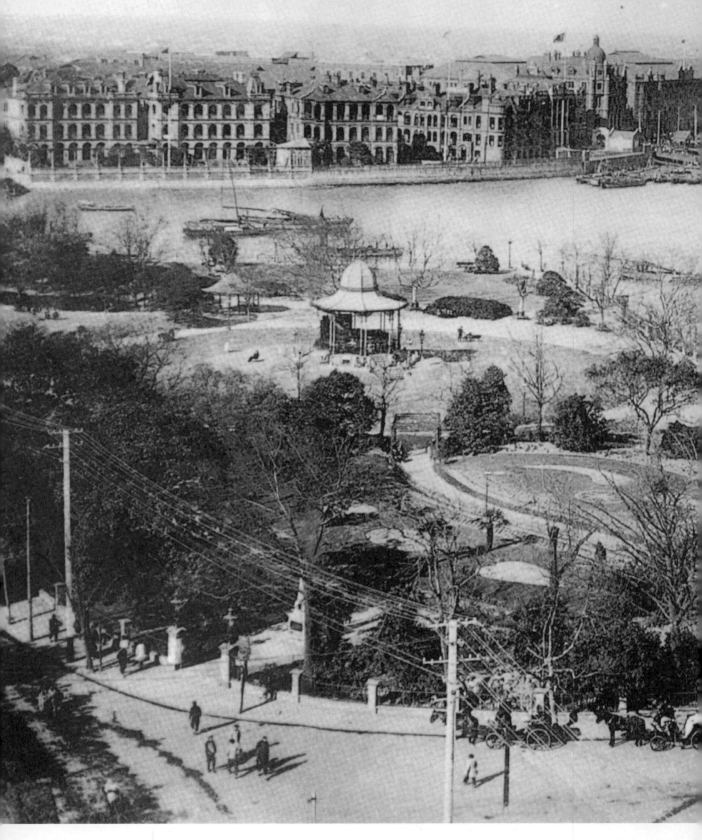

The Huangpu Park in the nineteenth century—this small and narrow park near the waterfront became well known later because of a dispute over racial discrimination.

sides often exchanged gunfire. Therefore it seemed reasonable that the Chinese would not be allowed into the park built by the foreigners. Many years went by without "the well water intruding on the river water" (meaning each side respected the other's territory). Both sides acknowledged that the 30.473-mu land belonged to the foreigners.

The year 1881 was an exciting one in Shanghai. On the sixth of April, a Sunday, several Chinese doctors associated with Saint Luke's Hospital—a hospital funded by the U.S. Christian Missionary—went together to the Park on the Bund to enjoy the warm spring day. They were stopped at the entrance. The doctors immediately wrote a letter of complaint to the Shanghai Municipal Council, strongly demanding that the council correct this mistake. They argued that the park was a "public" one; therefore everyone should be allowed in, with no discrimination against the Chinese. This incident was the earliest reported protest against the rules of the park.

Some Chinese no longer assumed the conventional attitude toward the foreigners—that they were the "devils and better to keep away from them." It followed that if the foreigners were human and the Chinese were also human, then these human beings were equal.

The doctors working for the Christian hospital obviously had Western educational backgrounds. They understood the difference between a "public park" and a "private garden." Perhaps they had just returned from studying in Britain or Germany and

missed the serene European parks, the freshness of the green grass, and the smell of white paint on the wooden benches, warm under the sun. The doctors complained that often those Westerners frequenting the Park on the Bund were uncouth and doing questionable business in Shanghai, unable to even write proper English. On the other hand, these Chinese doctors wrote medical records in English on a daily basis and were hardly suspicious characters. Perhaps they also loved Mozart's sonatas, which were popular among the doctors of the time. That was why they complained to the council.

On April 20 the council wrote back to say it intended to allow well-dressed, professional Chinese to enter the park. On April 25, however, another letter arrived that announced formally that the council had no intention of acknowledging the right of any Chinese person to use the park. In the end, the council decided to make no distinction and to say "no" to all Chinese citizens, professional or otherwise.

The doctors disclosed to the press the content of the council's letter. The reporters were scandalized, and voices of dissent were loud. *Shen Paper*, Shanghai's number one Chinese newspaper, further pointed out that the Chinese were the biggest taxpaying group in the Concession and should rightfully enjoy all public facilities in said area. This was another concept characteristic of a modern Western city—since the taxpayers supported the city and the normal functioning of all public facilities, they were the true masters of the city, not the administrators.

Do foreign children living in Shanghai behave themselves? Do they have identity problems?

In 1884 another narrow, long stretch of flood land appeared along the riverfront of the Park on the Bund. The Municipal Council again applied to the Shanghai Administration for permission to place landfill around that stretch of land in order to expand the park. When the administration went to inspect the land, they found that work had already started without its consent. The administration had been holding a grudge against the council because of the rules of the park for some time; now it had caught the council red-handed. The administration immediately notified the council that its conduct was considered an infringement and ordered the project terminated. This was the first confrontation between the administration and the council over the park and was quite a fuss over only a mu's stretch (about 667 square meters) of muddy land coming out of the river.

The dispute went nowhere until both parties appealed to the Shanghai Consular Corps. The Consular Corps served as a mediator, and it was agreed that the council had to obtain a permit from the administration before filling in the muddy stretch of land. The construction project had already been halted, but after a while the council took the liberty of starting work again,

(continued on page 78)

The Huangpu Park on the Bund—China's first modern park. During the 60 years when the Chinese strived for the right to enter the park, they learned how to differentiate between the public and private rights of a citizen and how to fight for their own rights.

The Bund has become a favorite place for the locals as well as out-of-town visitors.

The upper stream of the Huangpu River, Shanghai's mother river, which is mostly fed by water from the Taihu Lake in the neighboring Jiangsu Province.

enclosing the field and building the bank. The Shanghai Administration, upon learning of the work in progress, once again notified the British Consul and the Shanghai Consular Corps and demanded the enforcement of their agreement.

This time the council lost the suit and for a second time was forced to stop work. The British were adamant with regard to the park, and in 1881 their adamancy prevailed. However, this time their carelessness caused them to stumble.

In 1886 Zhang Shuhe, a wealthy comprador turned businessman, bought an attractive garden and transformed it into the biggest, most trendy Westernized entertainment venue in all of China. The Zhang Garden was free to everyone in Shanghai—Chinese, foreigners, men, women, seniors, and children. The area was bigger than the Park on the Bund, and the pavilions were several times taller. The prostitutes led Shanghai's fashion, and they were much more avant-garde than the foreign women in the park.

That year, the council finally acceded; for the stretch of land near the bank of the Suzhou Creek, they would allow Chinese

people into the park provided they wore Western suits or Japanese kimonos. In exchange for the use of the one mu of land in the park, which had sat idle for two years, the council agreed to fill in, at its own expense, another stretch of land in the Suzhou River and build a park especially for the Chinese.

In the same year that the expansion of the Park on the Bund was completed, a Chinese park was also built. It was a Western-style park, much narrower and smaller than the Park on the Bund. It also had Western-style wooden benches with backrests. At the center of the park was a small white stone fountain. The Park on the Bund was renamed Western Park. Nie Jigui of the Shanghai Administration chaired the opening ceremony in jubilation, and to celebrate, he wrote HAPPINESS ALL OVER THE WORLD on a big wooden board. There were rules for this small Chinese park based on the norms—drunks and improperly dressed people were not allowed in—but there were no rules forbidding foreigners to enter.

The year 1893 was the fiftieth anniversary of the establishment of Shanghai City, and a grand ceremony was held in the Concession. On the streets along the Bund appeared a

Old buildings are torn down to pave way for more high-rises in Shanghai.

banner that asked proudly and rhetorically WHO IN THE WORLD
DOESN'T KNOW SHANGHAI?

> Fifty years before, when a British man named Fortune first came to
> Shanghai, he predicted that Shanghai would replace Canton, which had
> opened first, to become China's preeminent commercial city and that it
> might even become a "far greater" place. Shanghai indeed lived up to
> this prediction.

Fifty years had passed, and the city became a buzzing,
exciting, and very rich metropolis, asserting itself, getting what
it wanted, and offering limitless opportunities. The penniless
Jews who had come to Shanghai earlier had become incredibly
rich. On the other hand, a large foreign firm that arrived at the
same time had collapsed. Its office on the Bund, a solidly built
tower, changed masters before getting worn-out. Following its
new master, the tower lit up and embraced new speculations.
It showed an aloof metropolitan style and seemed to have
acquired a jaded sense of "having seen it all." The tower was like
a flirtatious and sophisticated woman, who presided over big

occasions, could brave big storms, and who also knew very well how to show off and flirt. But it was too much for the ordinary people. People of small cities and towns, of deep secluded houses and big courtyards, cautioned their daughters in a seemingly casual way, worrying that the girls would be seduced by Shanghai. Shanghai was indeed a bit improper, and girls growing up there, even if they were still pure, could look flirtatious if they were not particularly careful when applying makeup. Somehow it took just a second for the rouge on the cheeks to bring out the appearance of looseness in the brows and eyes.

On June 1, 1928, all the Western gardens in the Concession started to open to Chinese. On that day 2,400 people bought tickets to enter the Park on the Bund.

Putting aside the old, mildewed book that I was reading in the Shanghai Library, I imagined the small, narrow park near the waterfront. After 2,400 people entered, the crowd must have looked like a gathering at a school playground or at the big winter sales on the pavement of Nanjing East Road or at a disco club on Christmas Eve. But could it still be called a park, even though people were rejoicing?

That year young Lawrence Kadoorie was going to school in Shanghai. He recalled years later that "there has been no other city, and there never will be one, which resembles Shanghai between the two World Wars. It was a hybrid of East and West and a city of sharp contrasts, a Paris in the Orient that combined

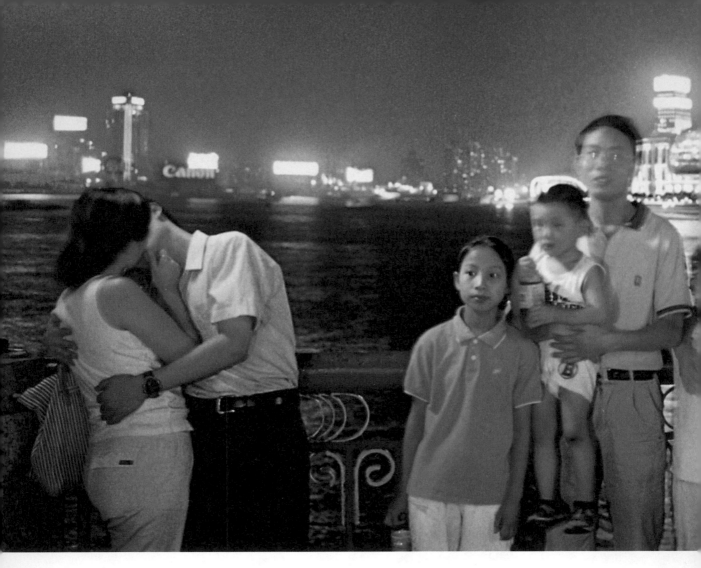

It is hard to imagine that the brightly lit Lujiazui Financial and Trade Zone across the river today was nothing but wharves and warehouses up untill the mid-1990s.

goodness and evil, and a paradise for adventurers. The international environment broadened our horizon and showed us how to become a citizen of the world."

So after 60 years parks in Shanghai were finally open to the Chinese and became the most desired places for the Shanghaiese to go at dusk in the summertime. On the wide expanse of refreshing grass, in the cool breeze, people brushed shoulders, sitting or lying down, "not giving a damn as to how they looked." The wooden benches on the riverbank were always fully occupied. No matter whether people knew one another or not, they sat close together on that one mu of land, over which there had been such a fuss between the Shanghai Administration and the Shanghai Municipal Council.

After 1928 the crowded yet still comfortable parks became scenes of local custom until, in 1966, the Cultural Revolution broke out. Occasionally there were people who came to the Park on the Bund, but after sitting quietly for a while, these were the unfortunates who stepped over the iron chains at the bank and jumped into the Huangpu River to kill themselves.

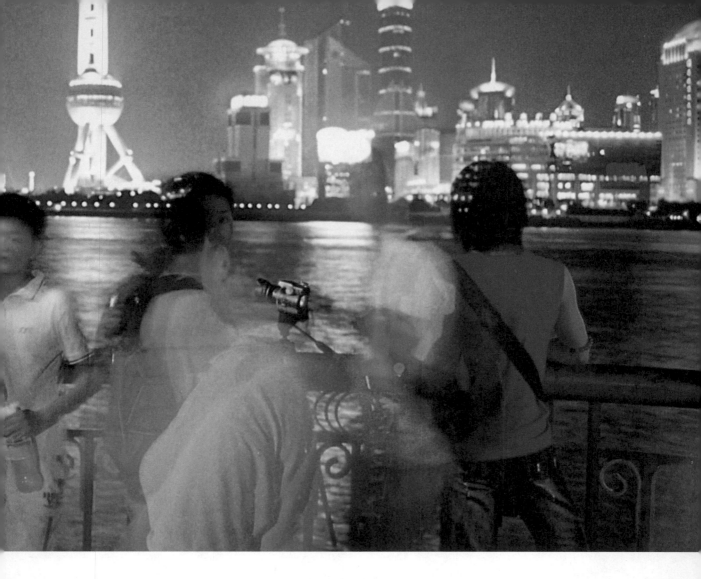

Yet as time went by and the sea changed into mulberry fields, the number of Shanghaiese on the grass and benches in the Park on the Bund never really declined. During the latter period of the Cultural Revolution, the park became a well-known lovers' retreat. When darkness set in, couples that had nowhere to go crowded there, taking some pathetic pleasures in caressing.

By 2003 the grass, the music pavilion, the chairs with backrests, and the "exotic flowers and grass" described often in the old books were no more. The park has become a parking lot for the big buses that take tourists to the Bund and to the most impressive public toilet in the city. On the stone stools people are seen sitting, staring off into space. Some are tired from walking and are about to take a nap, careful to keep their feet straddled over their bags. Some are taking pictures with their yellow Kodak single-use cameras, shouting loudly, "Smile, smile." I regard the smiling faces guardedly.

—A Fuss over a Park

My friend Nicole with all the cases is French. She rents an old Western house on Huaihai Road in the former French Concession. The house is deep down in a lane and was probably built in the later part of the Concession period, when the Spanish style was popular. It has red curved tiles, wide windows, and a balcony paved with red ceramic tiles; a sling chair made of woven rattan vines could be placed there. Houses like that are suitable for Shanghai, where sunshine is needed in winter and good ventilation in summer. Normally, three to four households would occupy a house like Nicole's, turning it into a shared residence. Both the dining room and the living room on the ground floor became bedrooms. The corridor upstairs became a kitchen for those who lived on that floor; the balcony was enclosed with glass windows to become a children's room. People even lived in the garage downstairs. The house was completely different until Nicole, who shares her home with a Dutch friend, has had the chance to return the whole building to its original design.

Nicole is not someone who merely rents an old house on Huaihai Road. With the archaeological training she acquired in Paris and the taste of a Frenchwoman who has lived in the Orient for a long time, Nicole decorated the house to look like the home of a French expatriate of the old times. She restored the parts of the old house that had been damaged by the previous residents. She scouted for furniture used by foreigners in old Shanghai and for local furniture that was usually bought by French people traveling in China. She found baskets made of rough willow twigs,

The French woman Nicole in her Shanghai home.

small stools made of bamboo, pointed straw hats, Chinese landscape paintings, and other furnishings, and used them to redecorate the whole house and the courtyard.

> Nicole's house is featured on the covers of foreign magazines and attracts foreign visitors who hear about it through word of mouth. She is very hospitable and welcomes all visitors. And when Nicole feels especially comfortable with a guest, she serves wine from France—a grand experience.

If a visitor is attracted to anything in her house, Nicole can place an order =for a replica. She has a small factory in the countryside, and her workmen create cream-colored leather couches, which were fashionable in the 1930s for those who have seen Nicole's couch and love it. Her carpenters can also make an exact copy of the traditional Chinese camphor wood trunk, which she uses as a tea table. Her prices are reasonable.

"You have no idea how the house looked when I planned to rent it," says Nicole. "There was nothing in the courtyard but an air-raid shelter dug in the past, not to mention the fact that

One of Nicole's suitcases.

several households were crowded here. All the steel window frames had been changed to aluminum-alloy ones. Only the floor was left unchanged, still the original Rangoon teak. After we cleaned the oil stains that had accumulated over the years, the floor underneath looked incredibly good."

"Do you make money from the house?" I ask her.

"Occasionally," she says. "When I meet someone I don't like, I will not sell to him, because he doesn't understand the value of what is here."

"And how is it that you know?" I ask. Then I realize I am being rude, so I say, "What I'm really interested in is your perspective. You have no background in Chinese culture, you do not speak Chinese, and you have no predecessors who used to live in colonial Shanghai, so why on earth do you spend so much time and money on a house like this in Shanghai? Your house is rented, and you will probably need to give it up when the rental period is over. But you still create a special world, little by little."

"Of course I know the value of my home," says Nicole. "I know much more than many Shanghaiese. See what you have

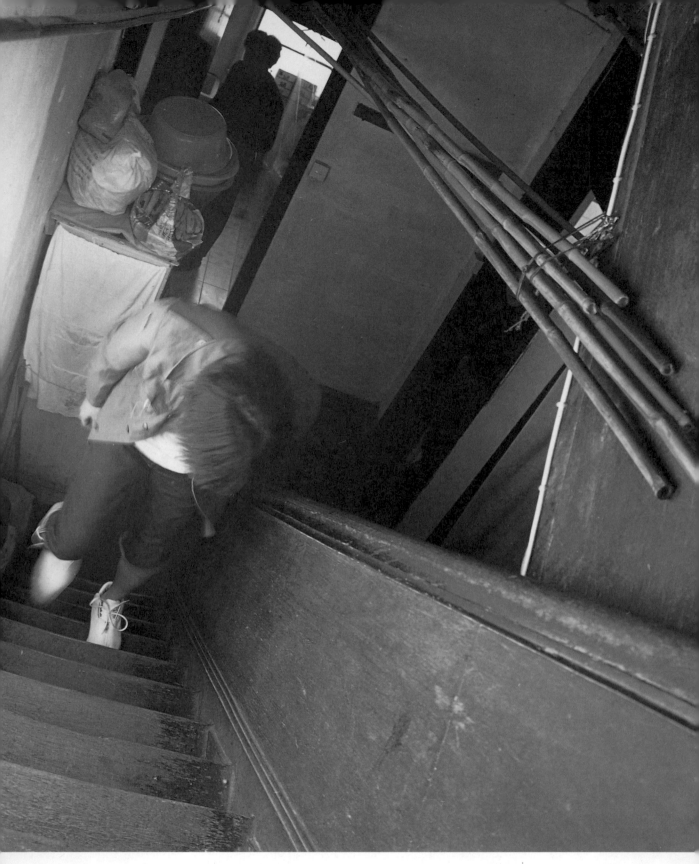

Wood staircase in one of Shanghai's old houses. For years several families crowded into what used to be a one-family apartment. The bamboo poles were used for airing the laundry in the hallway.

done to your city! You have demolished your traditions. When you move to another place, you throw away these beautiful things. Many things in my house, I have actually picked up on the street. Shanghai is not a city that knows how to protect its own culture."

Nicole then paces back and forth in her living room, showing me her collections piece by piece: a trunk, a small wood stool, and a standing lamp. "You do not know how surprised and happy the former owners were when they heard I wanted to buy the things they were using. Did I really want the stool? They were so surprised when I said yes that they told me to take it."

When Nicole talks about these things, there is a smile on her face—a happy, satisfied, and, I should say, a bit of a superior smile.

I see the trunks she collects carefully in the guest room—various old trunks collected in Shanghai, cardboard boxes made in Britain long ago, leather suitcases, Southeast Asian cases, French cases, small leather bags used by women for cosmetics. Most of them were used by foreigners who came to Shanghai a long time ago. They are piled up high, the smaller ones on top of the bigger ones. They remind one of those long-distance travels over numerous mountains and waterways, the dreams and ambitions that inspired those travels and all the tales that have been told. "When my guests visit, they put their cases here as well, and they become part of the story of my house," says Nicole.

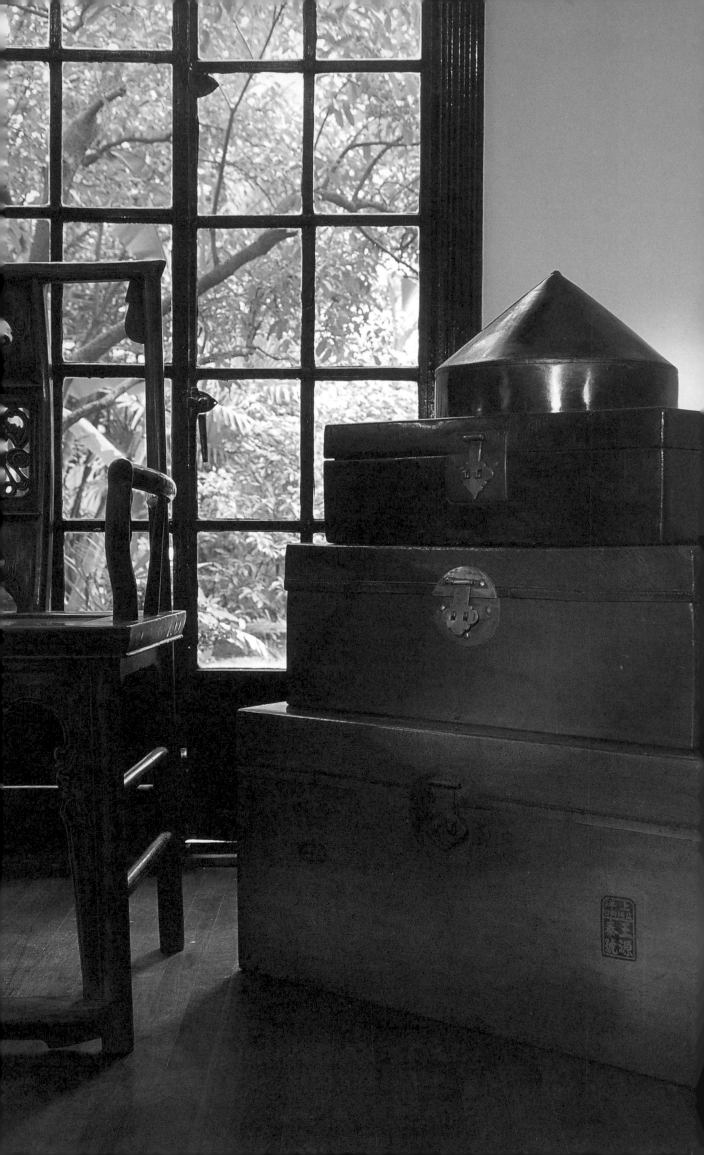

One of Nicole's proud collections.

To foreigners Nicole's house is the part of the Oriental style that is easily accessible to them. For Shanghaiese, we see in her house a modified and dressed-up Orient based on entirely non-Oriental tastes and backgrounds. To me, who grew up nearby, I see the former look of these old houses. They have always been around me, but they are as unfamiliar to me as the locked cases left by others. But Nicole, who rents an old house and restores its old look, who walks up and down inside her house making the spirits of the old residents resurface, is herself like a replica of an old master. That is the spirit of the French expatriates who came to colonize the city. They were full of the proud emotions of saviors and pioneers in the Orient. Nicole's eyes are shining in the shadow of the light, brighter after a glass of wine. I see that she loves her house and is proud of her work, her perception, and her appreciation.

—Nicole on Huaihai Road

Various traditional Chinese suitcases that Nicole has collected.

Nostalgia

A typical scene in Shanghai's old lanes: The old armchairs were put outdoors, and the sheltered lane served as a sitting room during the long summers.

Pick an afternoon with dazzling sunshine, go to an old building on the Bund, and walk into the entrance hall to watch the fight for space among the mailboxes. Seen from the outside, the old-style red mansion indeed looks like an old general, wearing his uniform on some anniversary. Walking inside, followed by the slanting sunshine that lights up the floor and columns in the corridor—the columns have hand-carved Baroque patterns, covered by dust that has been accumulating for years—you can see self-made mailboxes of various colors and designs, marked with different room numbers and names, occupying all the walls of the entrance hall, right next to the staircase.

The mailboxes belong to the families now living in the building. Each family, even a three-person family crowding into a single room, needs a mailbox.

This is why those mailboxes that are embedded in the wall behind an oblong piece of glass, marked with room numbers in bronze letters, are no longer used in some of the old buildings. In the past each household lived in an apartment; now several households share an apartment. They share the kitchen, the toilet, the corridor, and even the key to the entrance of the apartment, but they no longer want to share the same mailbox. So people make their own private mailboxes and hang them in the entrance hall. Seeing those mailboxes, no matter who you are, would make you think of the past and the present. Occasionally, when people living in the building are at home,

Haphazardly made mailboxes hang on the front door of an old building. They are marked with room numbers, each mailbox representing one family. Fresh milk is delivered daily to one of the boxes (lower left).

while their next-door neighbors are out, they will open their doors wide to let the air go all the way through the long, quiet corridor. They will hold a cup of tea and walk back and forth, thinking what it must have been like when the old inhabitants lived there and had the whole apartment to themselves.

You can also walk to the apartment where Zhang Ailing (or Eileen Chang, 1920–1995, a well-known woman writer) used to live, next to the Jing'an Temple, to see the elevator there. It is said that the old elevator has never been replaced—it was an old Austin. It still goes up and down reliably. But when you are upstairs, you cannot see which floor the elevator is on. That is because the display has always been the same old one, looking like half of a clock, a small red spot on the face indicating which floor the elevator is on. When the elevator moves up and down, a red iron pointer moves with it to indicate the second and then the third floor. But no one remembers the pointer ever moving. It always points to the top floor; it is no longer functioning. People who still use the elevator must figure out where it is by listening.

If you walk inside the old building, you can certainly see a lot more—the long, light brown floor planks in use for 80 years are still even, solid, and shining, when waxed. The thick solid doors to the rooms, made of a high-quality brown wood with bronze handles, carved carefully in the fine lines of patterns fashionable in Europe in the 1920s—an age of youth. Although the handles have been used for 100 years, their lines are still neat and distinct. In the ladies' room you can see the special

(continued on page 100)

新鲜每一天

光明乳业

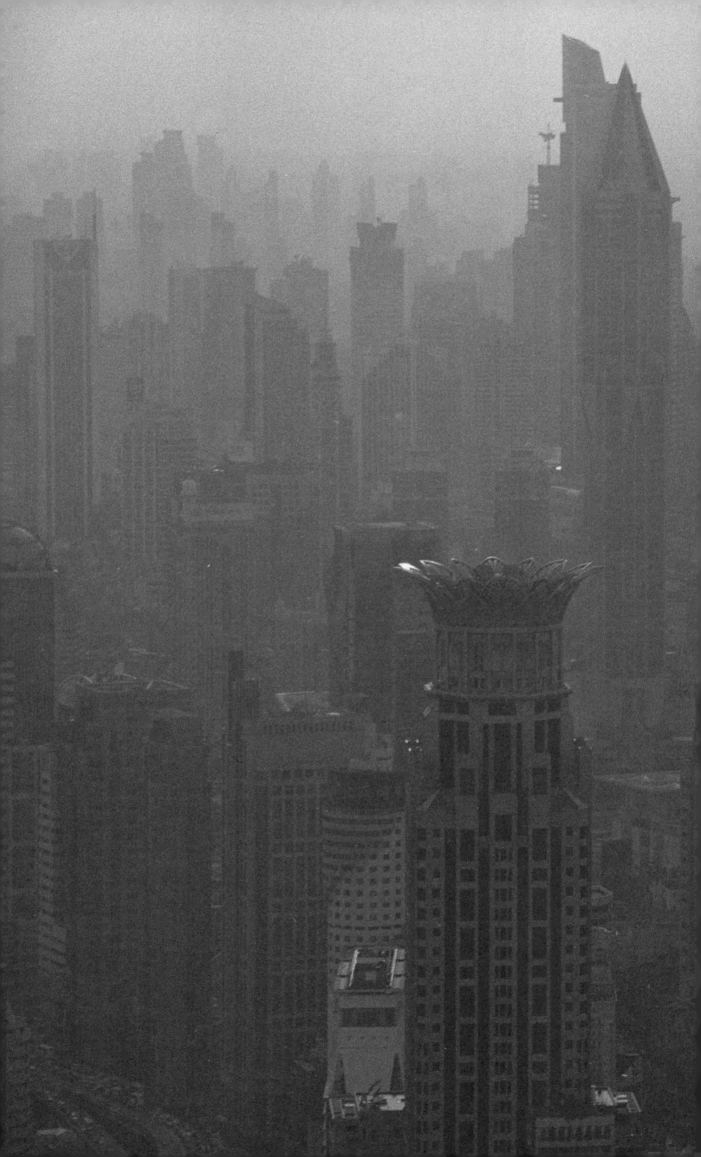

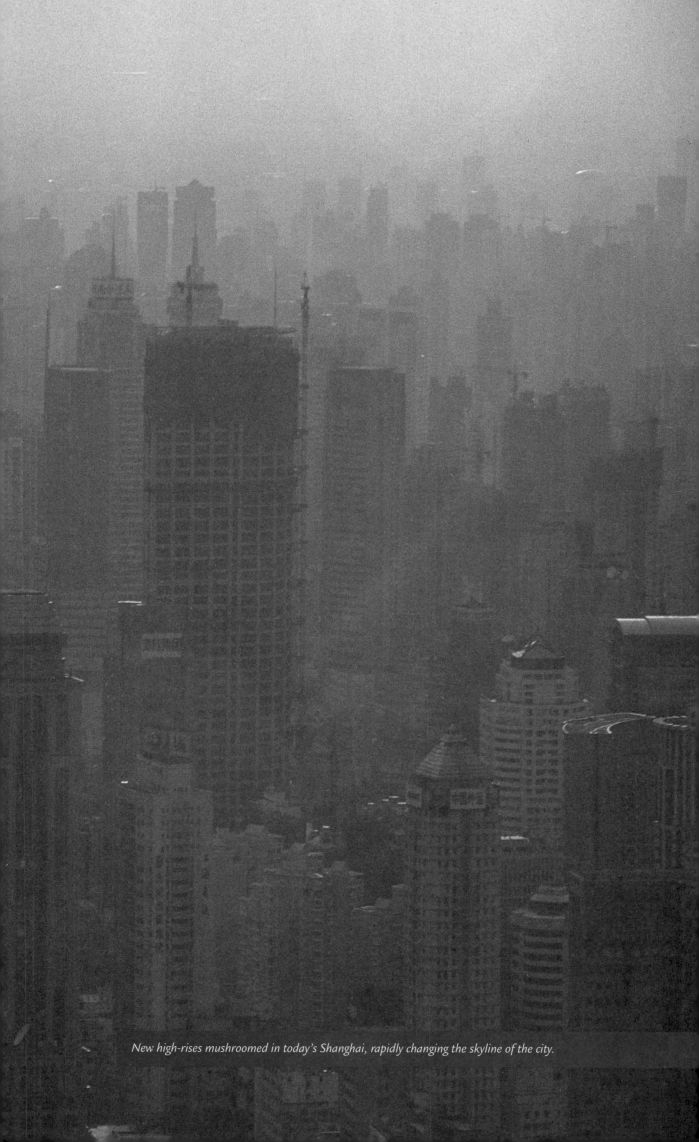

New high-rises mushroomed in today's Shanghai, rapidly changing the skyline of the city.

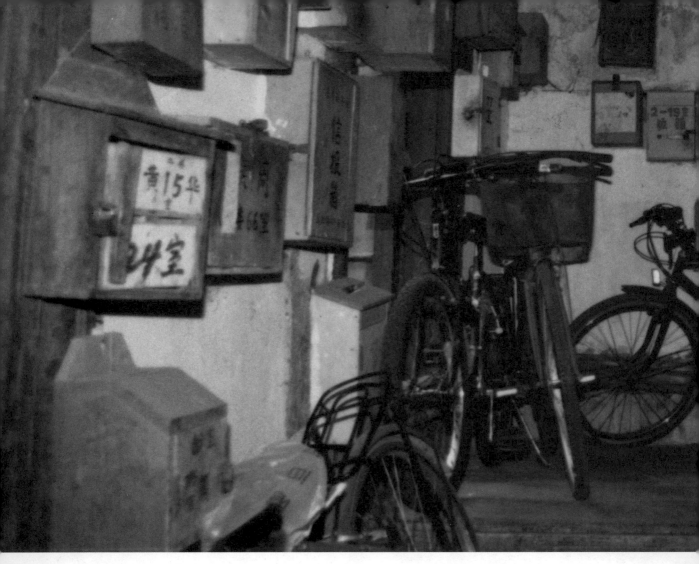

Mailboxes crowd the hall wall of an old building in central Shanghai. The hall is partly taken up by bicycles, still a major transportation vehicle for most of the people in the city.

washbasin, where the water flows up from below like a fountain. You will see the dressing mirror recessed in a wall of the corridor. The mirror reflects one's image in the dim light with smoothly pressed mercury and glass. It reflects people the way they are, with no distortion, no matter the distance from the subject.

As I see all this, words come from the bottom of my heart: In old Shanghai there were some exquisite, good old days. But if you put sentiment aside and really explore the inside of the old building, you will smell an accumulated mixture of oil, old wood, dust, food, urine from the small area next to the toilet, and soap from the drain of the bathtub. You will see that the tall, carved ceiling has become an indistinguishable black and white, with dust filling the patterns. In the kitchen, which also has a high ceiling, yellowish and brownish oily and smoky stains are everywhere. Where the oily stains meet the dust, a spiderlike web is formed; a strand here and another one there, looking like the strings used to hang small ornaments on a Christmas tree. Now another thought comes to me—how could anyone let this magnificent building fall into such ruin?

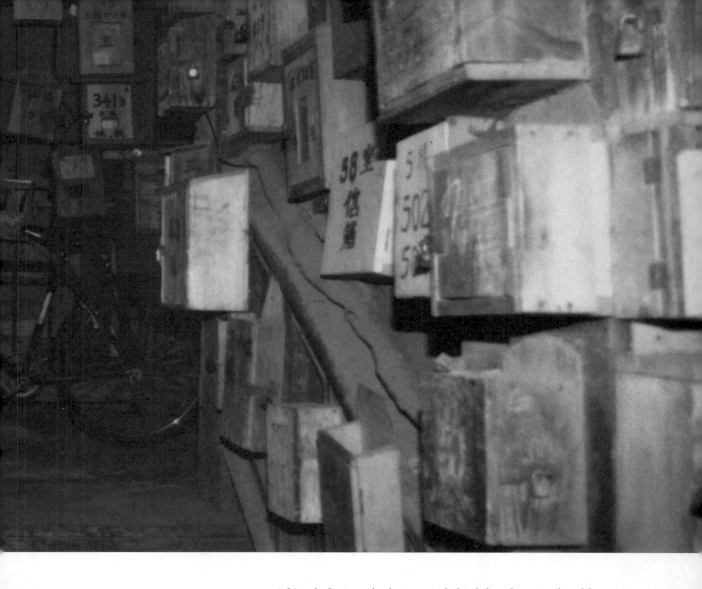

A friend of mine who loves to ride his bike, alone, in the old
quarter of the town on a misty night in early winter, when the
streets go quiet, the darkness of the night hides the dilapidation
of the old houses and the mist blurs things. He feels as if he
were walking on the streets of old Shanghai, when everything
was new and beautiful. He is one of those young, nostalgic
Shanghai guys who are full of sadness for the hometown they
never knew. Of course, they know it is not politically correct
to miss the Concession era, so they never use the word
"Concession"—they refer to "the thirties" instead.

Such young men are the firmest opponents whenever an old house in
Shanghai is to be demolished, or a Chinese parasol tree on Huaihai
Road is to be moved, or an American fast-food restaurant is to be opened.

Sometimes the old Shanghaiese do not understand them.
An old person who lived in the French Concession in Shanghai's
prime years said that one day, as he played in the street, he
blocked the path of a foreigner. The foreigner walked toward him
and made a rude sound, as if driving away a dog. The sound had
deeply insulted the Shanghaiese man. "Why should you be

(continued on page 104)

Derelict factory premises in Shanghai's suburbs.

A once well-known church was turned into a multifamily residence. Above: The electricity meters reveal the number of families living in this dilapidated building. Opposite: A strange mixture of the old and new.

nostalgic when you haven't experienced what we have?" he said.

Clearly, today's youths do not see the old Shanghai as it really was, and they did not live in a place that treated foreigners preferentially. So why should they be nostalgic for the old Shanghai? From what position, what point of view, do they possess this nostalgia?

Today's young people have not seen how foreigners bullied the Chinese. They do not know how unequal and unfair the old society was. When my friends grew up, women did not wear perfume and men did not care whether their fingernails were clean or not. It was a time of material deprivation, when there were no flowers on the streets. All they see are the dilapidated yet beautiful, refined houses left from the past, the remaining slices of life from those times, which inspire their imagination and nostalgia.

—Reasons for Nostalgia

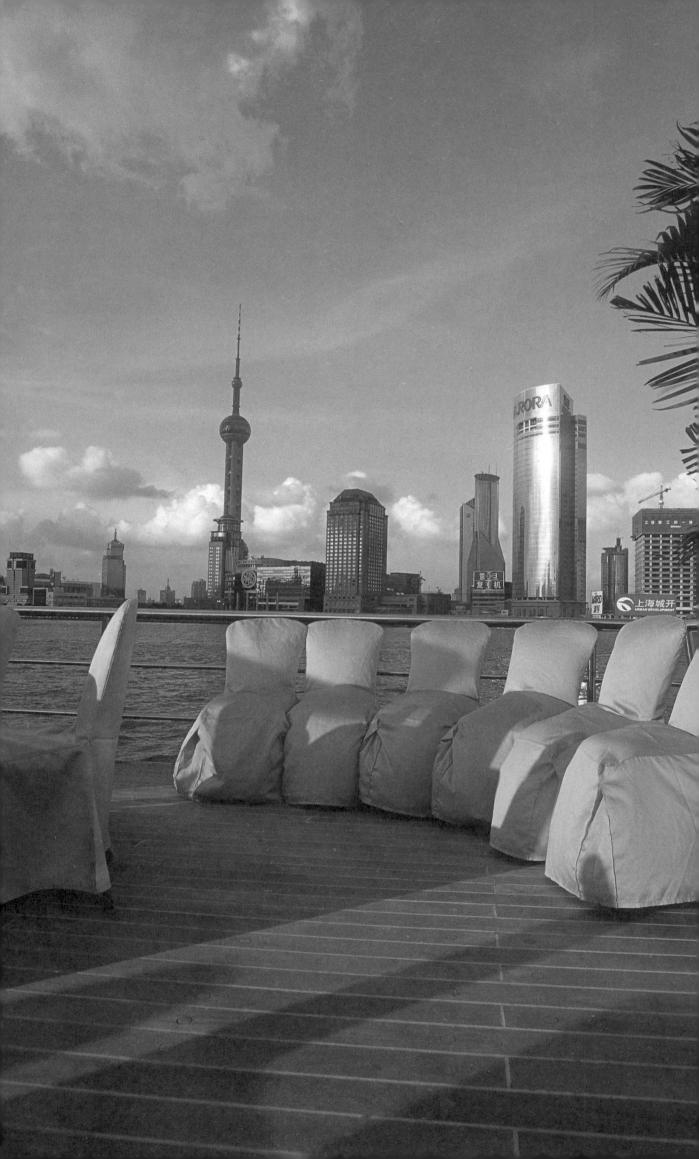

The Bund in the year 2000, as seen from a river cruiser.

The Shanghaiese often live a double life: One is for the street, where everyone is well groomed and well fed, looking happy and satisfied. The shops reflect the people. Facing the street, with their neon signs lit, everything glitters and stands up to scrutiny. However, the back door facing the noncommercial alley is a completely different story. There we see piles of unpacked merchandise and shop assistants walking along narrow passageways to report to work. What is shiny here are the dark walls; the passages are so narrow that people must pass one another with their bodies pasted to the walls, so close that their clothes practically polish the walls. Women are not dressed up, and lipstick prints appear on the half-eaten vegetable buns.

The other side of Shanghai life can be seen in the residential lanes and alleys, at home. People dress informally as they do their chores. Women wear colorful curlers in their hair while adroitly hanging their small carpets on the branches of the Chinese parasol trees that serve as clotheslines to beat off the dirt—the vacuum cleaner cannot do this task as well, of course. Men wear bright aprons to wash the dishes. This is a job that always falls to them because their hands are less likely to be ravaged by detergents.

The real lives of the Shanghaiese are hidden beyond the huge glass walls and the bells of the bronze American clocks. They do not want their true lives to be known; they value their privacy and wish to preserve their dignity.

—Times Café

What makes the secondhand shops in Shanghai different from those in Suzhou or Hangzhou are the old items from the West, left over from Shanghai's "Concession" period.

At about that time, a young couple pushed open the door of the secondhand shop. They looked like educated people, slim and well dressed. There was a set of pottery, a pitcher, and a basin on the floor in the corner, decorated in an enchanting Western style, with a light brown, fine and dense pattern painted with gold lines. The woman exclaimed, "How pretty!"

An old man who leaned on the counter near them said, "One hundred yuan for the set, very cheap. Things like these, I'm afraid, you won't be able to buy later on. People buy them and put them on display as antiques."

The younger man squatted on the floor and said, "So do we." He opened the pitcher and said, "There is a crack inside."

The woman said, "It would look pretty on our hi-fi; we can use it to hold flowers." She raised her head toward the old man: "There is always a set of these things in old British movies. People put them on the wardrobe."

The old man looked at them. "These were left by foreigners of the Concession period." Then he couldn't help saying, "It is not easy to find things like these today."

The woman nodded, then added, "There should also be a jar for water."

The old man said, "That's right. It should be a set of five pieces. There should also be a mug and a soap holder. It's almost impossible to come by an entire set these days. These are not used much even abroad, I guess."

The man and the woman stood there on each side of the

(continued on page 112)

Looking at the antiques in the shop, one can perhaps "feel" the city life of the old days or the vanishing way of life in Shanghai, illustrated by the old mosquito-net hooks no longer in use.

The author, Chen Danyan, still wears on her wrist the Omega gold watch made in 1950, which she inherited from her mother.

pitcher and basin and said, "They are so pretty; it would be just fine displaying them at home, even if they don't appreciate in value."

The old man said from where he stood, "It won't be a bad deal. People simply cannot create the same feeling today, no matter how hard they try to copy."

The woman looked at the old man attentively and nodded, "That's right. I wonder what the story is behind these gorgeous old things. A Madam Butterfly story maybe?"

The old man smiled and said to me, "I really love it here. One encounters the few truly well-educated people of good taste who are still around."

The couple bought the pottery basin and pitcher and then went to look at a box of dining knives. The old man carefully placed the box on the counter; the box gave out a mysterious smell—an exquisite smell truly reminiscent of times long ago. The old man meticulously counted the knives one by one. "This is the fish knife, and this is for cutting bread. The blade is serrated, so it won't crumble the bread."

The woman said appreciatively, "Look at these knives. They remind me of the scenes in many films—tablecloth, flowers, candles, castles." She stretched out her hand to touch the white cloth underneath, which already had some yellowish rust stains. There were small, tidy letters in gold on the cloth, and she said, "The Shanghaiese hopelessly admire everything foreign, to their bones."

A miscellaneous assortment of old articles, from mandarin-like chinaware to alarm clocks with clock faces of Chairman Mao and the workers, peasants and soldiers, sit together in peace.

"There used to be loads of stuff like this in the secondhand
shop on Huating Road," said another man who had been silent.
I immediately turned to look at him but didn't recognize his face.

The couple bought a small box of dining knives and left. The shop returned
to quiet. The songs of Perry Como stopped from somewhere. The only
sound to be heard came from the clocks-and-watches counter. The old
clocks and watches made an aged yet grand sound—*tick, tick*. The old
man leaned on the counter, now short of a small box of dining knives.
His silent face blended well with the sound of the ticking.

—The Secondhand Shop

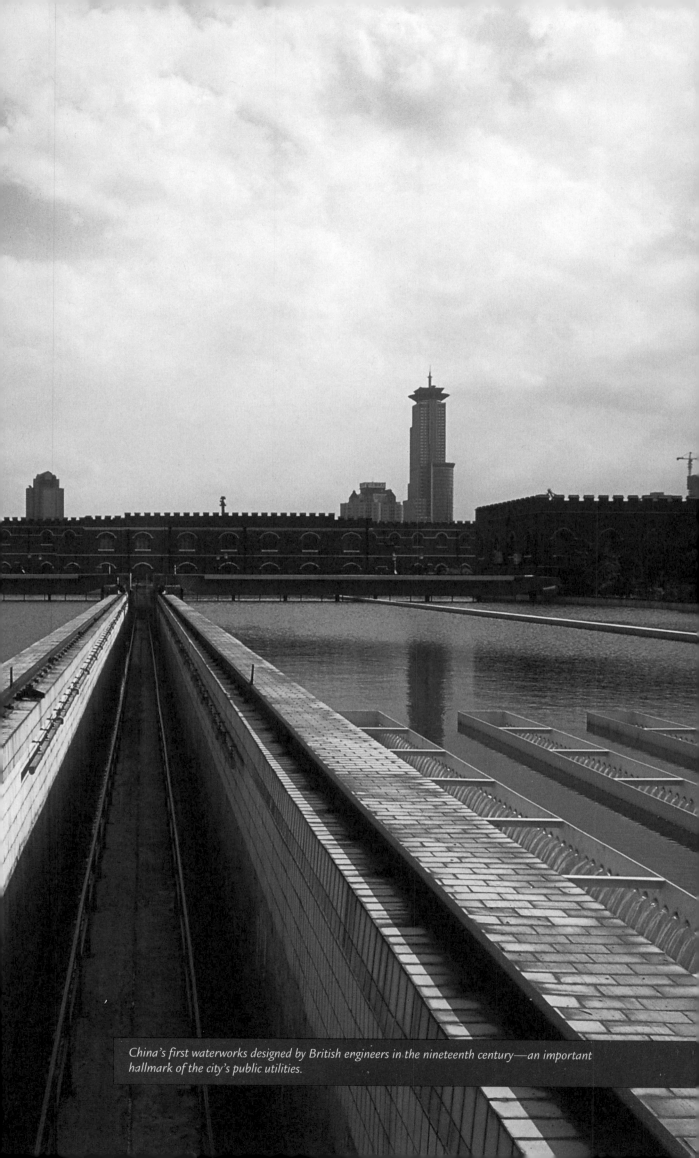

China's first waterworks designed by British engineers in the nineteenth century—an important hallmark of the city's public utilities.

Accordions like this used to be the only musical instrument for many choirs.

In the courtyard near the river, the air was filled with the damp smell of night, and the big house with white gauze curtains was brightly lit. Through the big open gate, worn-out light brown wallpaper could be seen, along with a very big, complicated-looking, old-fashioned pendant lamp. Countless glass pieces, yellowed with age, hung from the lamp. They were as flowery as pieces of brocade, looking the worse for wear, yet still crystal-bright under the light. Music floated out, then retreated, then repeated; the scene was rather unusual in Shanghai in the early 1970s.

It seemed as though those houses left by foreigners from the colonial period, which looked dilapidated in the daylight, suddenly come alive when darkness set in, in the dim yellowish streetlights and the thin fog of the spring evening. They were like dying embers that suddenly flared up, lively and bright. There was a romantic feel about this remote place. It was like a big ship sailing in the sea of the night, proudly revealing its beauty while slowly but unstoppably going away.

(continued on page 123)

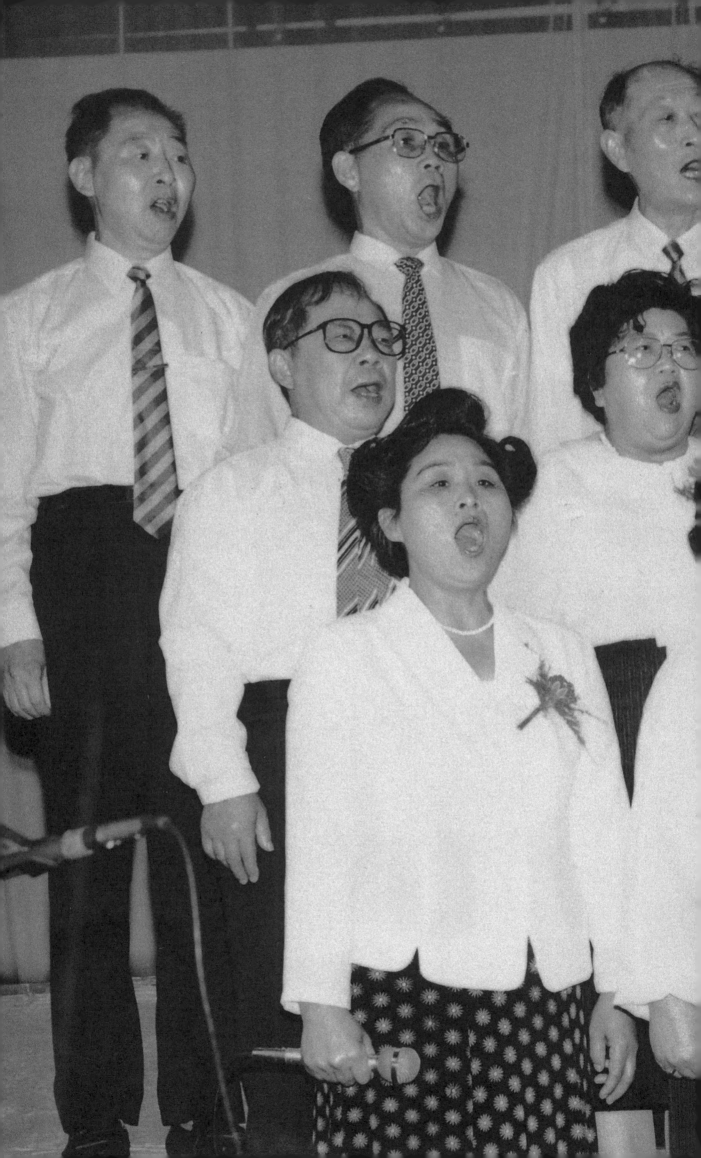

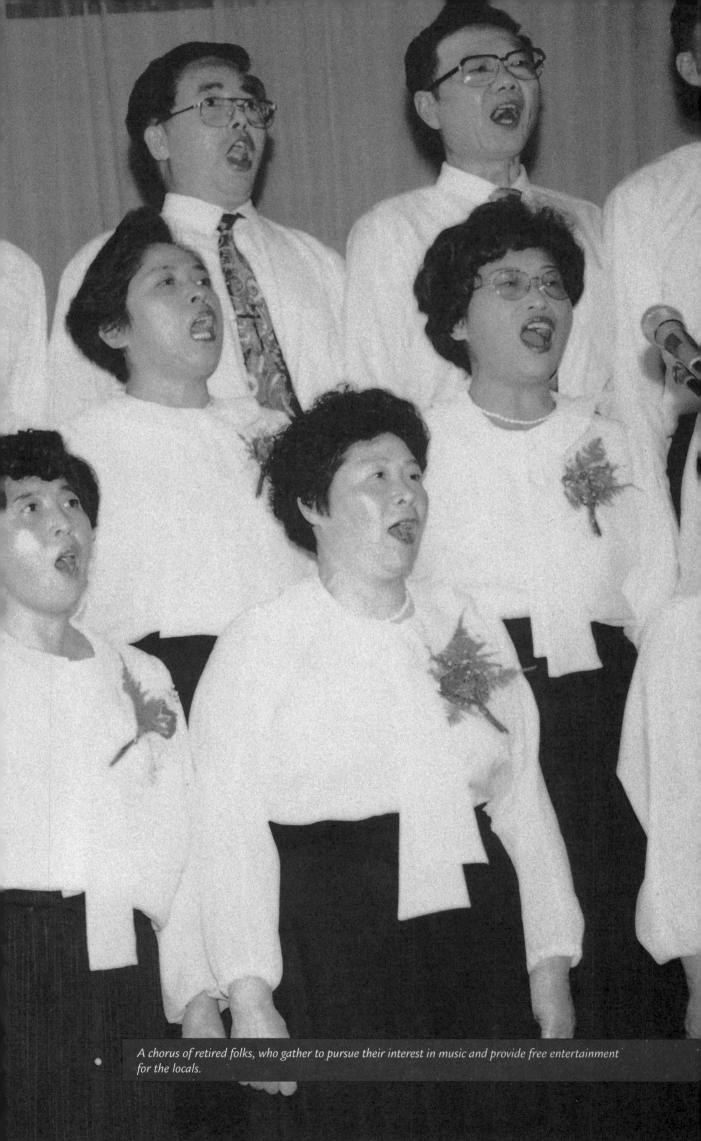

A chorus of retired folks, who gather to pursue their interest in music and provide free entertainment for the locals.

Granite exteriors are a common feature of most of the buildings on the Bund.

At that time, we all had gone through many years of poverty and constrained living, totally and cruelly deprived of our private thoughts and personal space. Out hearts were barren and hollow. But when we stood in front of those bleak places, we could still fantasize about another world, a world that was exquisite, different, and gentle—a world we had never seen. We watched that house with surprise, regret, and sadness.

"Andre, there!" Wang Lian nudged me.

The director strolled in our direction from a nearby side street. He, too, was watching the house and listening to the music, as if he had come to revisit a familiar place. We had not quite made up our minds whether to hide or not, but he saw us. We then said to him, "We came to find a toilet."

He nodded and then said, "A beautiful house, isn't it?"

"Yes," we replied.

"This is an early-eighteenth-century European architectural style," he told us. "In Europe there are many houses like this. People actually lived in them, not like here, where they are used for some sort of club."

He talked about Europe just like that, a bit inarticulately, as if he couldn't help talking about a very intimate but secret friend. "Europe, Europe," he murmured fondly. Ironically, at that time he had not even been to Europe. He was merely a young Shanghaiese in the early '70s who lived in a house built by Europeans in 1925 and who listened to eighteenth- and nineteenth-century European music, who carefully collected

European coffee cups from an unknown period, and who used a bottle marked SALT as a pen stand. He meticulously gathered fragments of European life as if he were decorating his sky with stars.

It was the director who implanted the image of Europe in that barren field that was my heart—that symbol of an indescribable, unimaginable, yet beautiful life. Like the root of a tree, it grew crazily, roots twisting and branches gnarling, unstoppable, forever.

On that day the three of us stood near the dark ilexes and listened to the sound made by the hard-falling leaves in the spring. We watched the big house temporarily lit up by the lights at the bank of the Huangpu River as if we were watching a world behind a shopwindow decorated with only the finest things.

—The Night of the Performance of the Choir

Each and every old building along the Bund has had its day. Shanghaiese have mixed feelings about them.

Family dancing parties may have been held here.

In the windless night of winter, it was dark and cold, wet and misty on the streets. There were not many passengers after nine o'clock. Seen from afar, the street lamps looked like circles or stars in a van Gogh painting. There was no heat inside, so every household had shut its door and windows tightly. Housing was in dire shortage in Shanghai. Many families had to live in one room, and on the windows there were streams of water vapor. It was the Shanghai of the '70s.

Walking on the streets in the darkness of the night, one saw some Western-style houses left from semicolonial times—the winding and ascending Spanish steps, the long and flat English chimneys, and the Baroque relief on the lintel. The darkness of the night concealed the age, the dilapidation, and the crowdedness of the houses while bringing out their exotic beauty and the mystery of a history carefully wiped out.

Someone ran up in a rush and knocked on the door. The sound resonated in the long lane and was heard from afar. The door opened. It was very dark at the bottom of the staircase. There was the smell of rib soup with cabbage—everyday home cooking in the winter.

Inside the room, the curtain was pulled tightly over the window and made the light feel dimmer. Pushed next to the walls, there were some chairs, and people sat with their coats on the backrests. Girls wore wool sweaters—you did not see girls wearing body-hugging clothes that revealed their figures on the streets. Here the girls all looked startlingly beautiful, and they

The cover of one of the issues of the Shanghai Songs *magazine, published in the 1930s.*

knew it. Their eyes, under the reddish light, were shining like those of a cat. The big bed had been dismantled in advance to create space for more people, so the room looked a bit unfamiliar. An old-style recorder was placed on a chest of drawers, along with a big pile of LP records, each in a brown paper envelope.

Often someone would bring a Japanese-made stereo cassette recorder, which had just become fashionable. It was a Sanyo, and there was a big black speaker on each side of it, like rouge applied to the big, wide face of a rural woman. They would play Teresa Teng's songs. People of that time were not attuned to such a soft voice, and they often fell in a daze while listening to her songs. Friends would bring other trusted friends to join the party. Some brought cassettes of English songs they had managed to copy from somewhere. Whoever was able to translate the lyrics would have a girl or a boy instantly falling in love with him or her.

Many love stories at the end of the '70s began in this way. It seems that many people started learning English when they heard an English song at a family dancing party.

Dancing schools like the one in the picture once trained dancing girls. Some of them appeared on Shanghai's streets and in alleys before 1949.

Looking back, one can see that the era of darkness also had its own quiet romance.

"You are painting Shanghai," I said to my friend.

He said, "Yes, at a family dancing party."

When a song was played, partners sat there and counted out the steps—was it 3/3 or 4/4—before standing up. Then they walked into the middle of the room, a bit shy, and got started. Nobody danced really well, so no one could really tell who the beginners were. They watched their feet nervously, self-conscious about the size of their feet, which seemed so big, like those of a duck. The newcomers were hesitant, like chickens eating rice. Before one song finished, they were already sweating and holding on tightly to their partners.

Of course, there were those who were born confident. They took big strides to the music, as if marching in a military drill. One man held his partner in a grand and dramatic stance, like a drummer in a military band holding his drum.

There were many women who danced better than their partners. However, as soon as they tried to lead, the steps were

(continued on page 132)

An advertisement for a commercial dance hall on a torn-down building wall in the 1980s Shanghai. The big red character wu means "dance," while the two-line Chinese characters say "Let your graceful dance evoke memories of your youth."

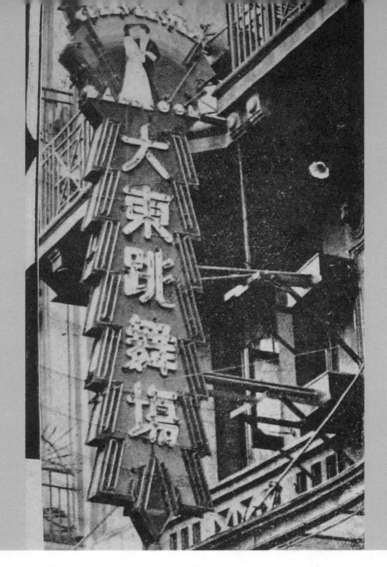

A billboard for a commercial dance hall in the 1940s.

all wrong. The partners then had to count, "One, two, three, four. One, two, three, four."

> Normally a man would not accompany his partner back to her seat. As soon as a piece ended, the partners would immediately withdraw their hands. The man would leave and the woman would leave also, as if they did not know each other.

Even when people learned to dance to the music, they did not know what to do at the end of a piece. Some people would just stop and stand in one place, obviously not knowing what to do. Now that I think about it, the explanation for the embarrassment is twofold: clumsy manners because of a lack of proper education, and shyness. You simply did not hold a lady in public without a good reason.

In winters past, people often wore home-knit wool pants to keep warm. When they came into the house, they usually took off only their coats, so the lower part of the body looked much bigger than the upper part and the waistline looked extremely slim.

Is this old factory workshop going to be turned into a dance hall?

No long dresses, no black evening suits, no bows to invite a partner.

Perhaps those were the days that least conformed to the established practice of ballroom dancing, which was first introduced in Shanghai in 1843. At that time people danced in Richards Hotel near the river, but then, in the 1970s, they danced in a bedroom where the floor made a creaking sound. However, people were not dispirited. The music, though turned down low, was still beautiful, and rocking to the music with a special partner of the opposite sex was still so enchanting.

Waltzes remind one of romance, while the fox-trot takes one's thoughts to a faraway and glamorous world. Old people often look at my friends and me with the air of those who have experienced what we cannot, and say condescendingly, "You will never see Shanghai as it was in its former glamour. You have become rural people." God bless us, we are not old yet, but we can still dance the old dances, even in home-knit wool pants.

—Fox-trot in Shanghai

I n the 1980s, the waiters upstairs in the Red House Western
Restaurant were actually people who had seen a lot and knew
a lot. They saw all sorts of privileged people in Shanghai when
they came here for a Western meal. At that time the Red House
was the most famous Western restaurant in Shanghai, and those
who ate there took the dining experience quite seriously. Even
for the more established families, eating at the Red House was
a somewhat grand occasion. For many years, dining at the Red
House was a chance to observe those people who always
demanded a bit extra, no matter the circumstances. It was a place
where one could guess a person's background from the way he
or she ate.

At the restaurant one could wonder about how much the
world had changed and still enjoy a bit of the old lifestyle.
Affected by the light and weak smell of coffee—made by either
the Shanghai Coffee Factory or Yunnan Coffee Factory—diners
tended to allow their fantasies to run wild. Some liked to pretend
they were someone else; others, however, could not help but
reveal a bit of themselves, like the Arabian daughters who pulled
their veils down briefly. Very often, indulging in a French meal,
served Shanghai style, helped the guests keep their spirits high.

At that time there was also an expensive French restaurant
called "The Grill" at the Hilton hotel; people without loads of
FECs (foreign exchange certificates) need not enter. The bill
reportedly started at 250 FEC plus a 15 percent service charge.
Only those foreigners who were completely lost and knew nothing

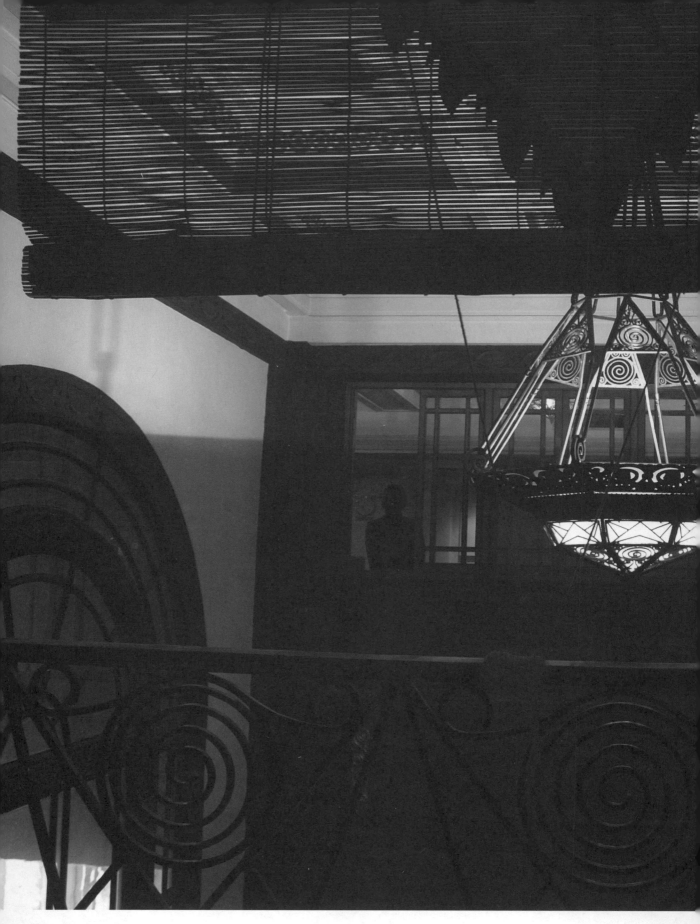

The interior of a Western-style restaurant in Shanghai.

about Shanghai or the vulgar nouveaux riches would go there. It was said that in The Grill there were whole sets of stainless steel tableware, and different knives and forks were supplied for each course of the meal. According to the rules of etiquette, one should use the knives and forks pair by pair, from the outside in. However, none of the nouveaux riches knew how to use them. They would grasp the fish knife to cut beef, using all their might, until their thumbs turned white.

In the Red House, however, there was only one knife, one fork, and one spoon, and none of them were made of silver. Among the guests, one often saw those who ate gracefully, even if it was only a fried pork chop. When they ate, the knife and fork would not clatter on the plate. Their mouths were clean and so was the table. When they finished, they knew to place the knife and fork on the plate in the same direction. These people never went to The Grill.

Some people who came to the Red House were not well versed in Western table manners. When they sat down next to the long table, they hesitated a bit, fearing others would discover their lack of sophistication.

They glanced at other diners to see which hand took the knife and which one the fork. And when the soup was almost finished, they took note of the direction of the spoon—toward the diner, or the other way. Then they reviewed everything in their minds.

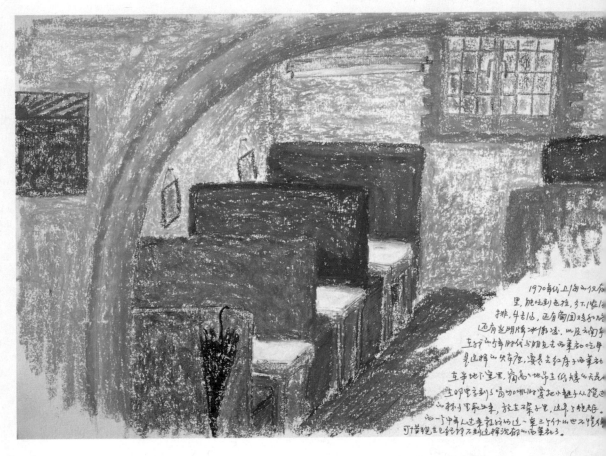

An artistic rendering by the author of the interior of a Western-style restaurant in the 1970s Shanghai.

When the waiters saw people holding their knife and fork as if they were heavier than hammers, they explained the proper protocol to the guests when they ordered: It was possible to order onion soup, or oxtail soup, or potage à la paysanne, or cream of mushroom soup. Each serving was for one person. It wasn't acceptable to order onion soup and oxtail soup, place them in the center of the table, and let everyone extend a spoon. The main course would not be brought to the table until the soup was finished, so one could not keep the soup to go with the main course. If that were the case, no one would ever get the main course! Each person was to order only one main dish—no need to order more. The bread was free. The flambéed ice cream actually came with coffee after the meal.

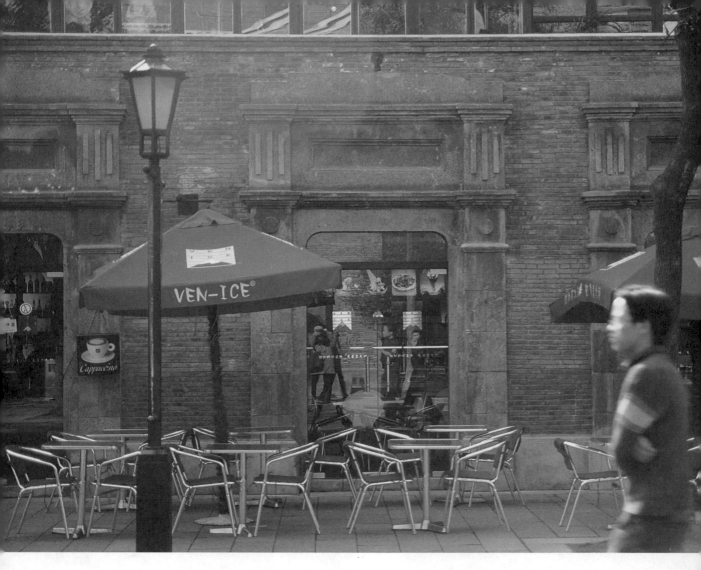

VEN-ICE is one of the many Western-style restaurants that opened in the late 1990s.

The waiters explained the rules loudly, not caring if the guests were embarrassed. In Shanghai everyone knew how embarrassing it could be to show one's "greenness."

Actually, the waiters did not intend to make fun of anyone; they really were trying to help the guests have a proper Western meal. When they would see diners tucking one corner of the tablecloth into their collars—the way Khrushchev did it—using the tablecloth as a child's bib, the waiters didn't say a thing. After all, it was the "Russian style."

—Red House Western Restaurant

The look and feel of the old part of the city. The cast-iron door decoration is a reminder of the colonial Shanghai before 1949.

Boiled potatoes are an essential ingredient in the typical Shanghai salad.

There is a cold dish that you can order in any restaurant in Shanghai, small or big, Chinese or Western. It is salad.

Shanghai's salad is a mixture of boiled potatoes, cut into small square pieces; an apple, also cut into small squares; some boiled green beans and sausage, again cut into small squares; and all are stirred in salad dressing. According to people from the Red House Western Restaurant, salad like that was served as an appetizer as early as 1930, when Red House's two outlets were opened.

Salad is a dish with a long history in Shanghai. In the '70s and '80s, when there was a shortage of ingredients and the country was culturally closed, salad was often served at family dinners and people felt it was stylish.

The Chinese name *Se La* was directly transliterated from the English word "salad." For many of the other foreign things that have become part of everyday life, the Shanghaiese have given them pidgin Chinese names, taken directly from English.

However, this particular cold dish did not come from America to the people of Shanghai, not from Germany or France, not even from Russian restaurants that were all over the place in the Huaihai Road areas after the October Revolution. Perhaps Shanghai's salad is similar to potato salad in Russian cuisine, but then, the Shanghaiese habitually add sausage and apple. It is different, after all. Europeans and Americans in Shanghai did not know that salad had become a cooked dish in Shanghai. The

lead chef at the Red House says that salad like that was a *Fan Cai*, the name the Shanghaiese gave to "localized Western food" a hundred years ago.

In fact, we should regard it as an authentic Shanghai dish. It combined French fruit salad, Russian potato salad, and cooked food loved by the Chinese.

In the 1970s, when one could not find bottled salad dressing anywhere in Shanghai, most local kids knew how to stir egg yolk in salad oil with a pair of chopsticks untill their hands ached, to produce some homemade mayonnaise to use as salad dressing. In the '70s and '80s, when it got really difficult to maintain something of an urban lifestyle, there was only Shanghai, in all of China, where one could buy unpackaged salad oil in the oil-and-sauce shops, at 0.82 yuan a jin (0.5 kilogram), to make mayonnaise to be used as salad dressing.

Home-made salad dressing is essential in Shanghai salad. It starts with an egg yolk, which is stirred and whipped in salad oil with a pair of chopsticks. Typical ingredients include boiled potatoes and an apple, both diced, plus some boiled green peas and sausages (again diced). They are mixed in the mayonnaise-like salad dressing in a bowl.

The Shanghaiese are very much attached to their carefully created and meticulously preserved lifestyle. People who have always lived in Shanghai are not really conscious of it. But once they leave the city, they feel it very strongly. Those who leave to follow their dreams never change their lifestyles just because they have left their hometowns. They never follow the local customs wherever they settle. The Shanghaiese think of themselves a bit like Jews. They have a combined Chinese-Western lifestyle that is almost their religion.

After the 1970s Americans no longer called their country, especially a city of immigrants such as New York, a melting pot. They no longer wanted to create a single American identity for people from all over the world, of all cultural backgrounds. Instead, they have a new slogan: America is a plate of salad—all nationalities and cultures are welcome to keep their original identities, individually. However, in Shanghai, even a plate of salad has been reinvented to reflect the ways of the locals.

—Salad in Shanghai

Localized Western meal at home: rice with seafood, salad, sausages, bread, and a vegetable soup.

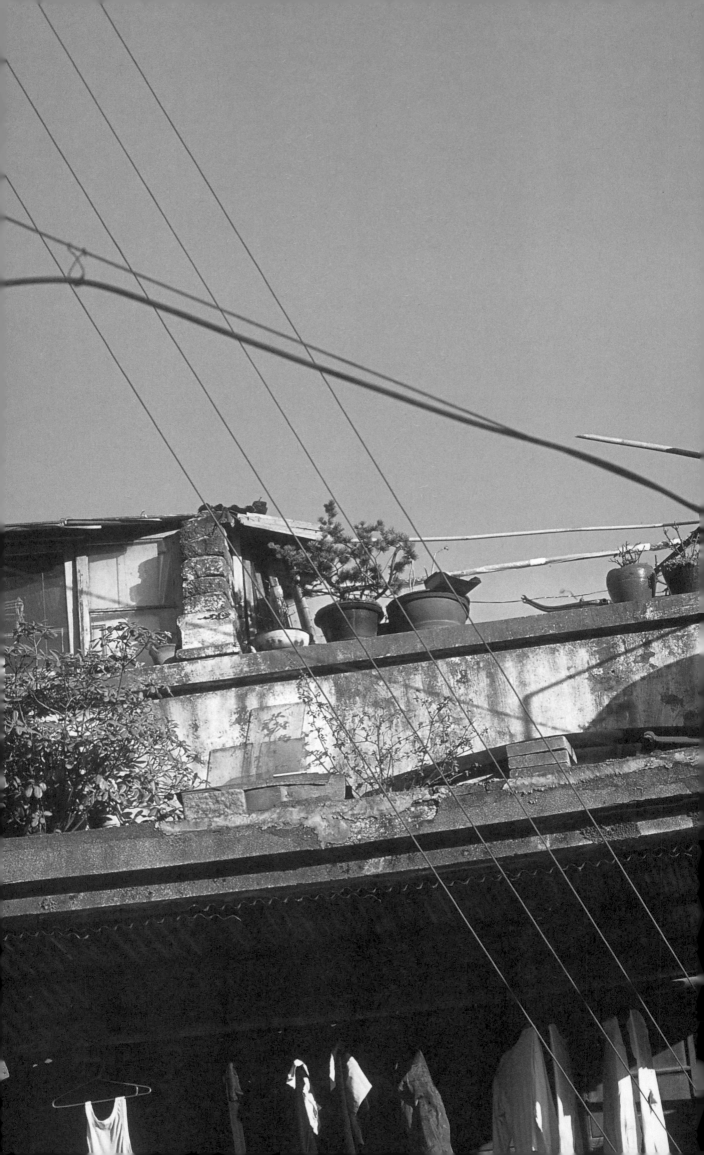

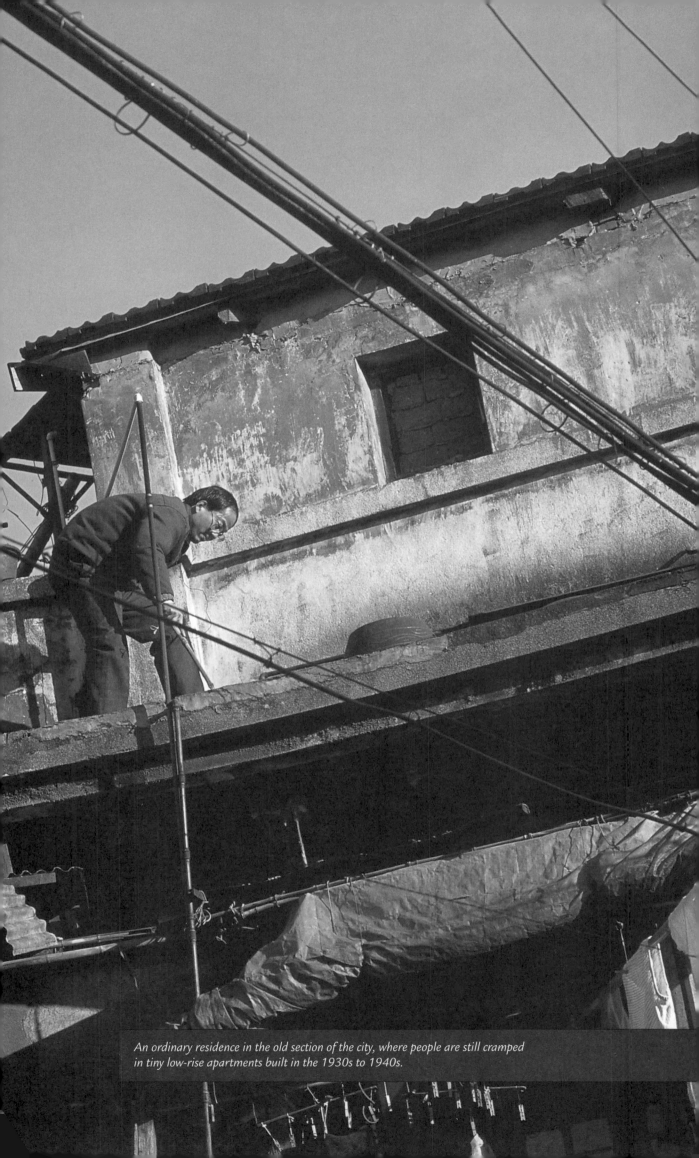

An ordinary residence in the old section of the city, where people are still cramped in tiny low-rise apartments built in the 1930s to 1940s.

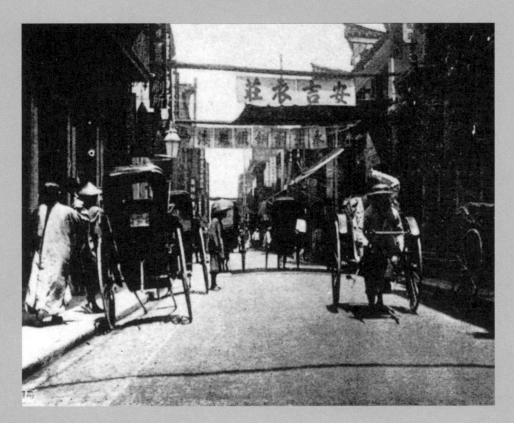

Picture of a Shanghai street in the early twentieth century.

A Shanghai street in one of the drawings of "Tintin at Sea" by the Belgian cartoonist George Remi. It looks stunningly similar to the picture on the opposite page.

At the intersection, under the dim, old-fashioned street lamp, we saw an old man with a red-liveried rickshaw. The light from the lamp was blurry and yellowish, projected on the narrow street without a single tree, and made the street look like the deep ditch remaining from a demolished building. The old man and his old rickshaw waited in the crack of the old building, as if they were accumulating dust over the years like a history book. I remembered hearing in a documentary that there were only seven genuine rickshaws left in all Shanghai.

The old man wiped the seat hard with a seemingly whitish towel and said to us in a loud voice, "Take my rickshaw and have fun on the Bund. That will be just right."

The seat was covered with white cloth and felt hard when you pressed your hand on it, like there was oilcloth underneath. People in the past must have been slim, because when the two of us got on, we had to sit tightly pressed together.

When we asked about the price, the old man stretched out two fingers, meaning 20 yuan. Then he told us to go from the

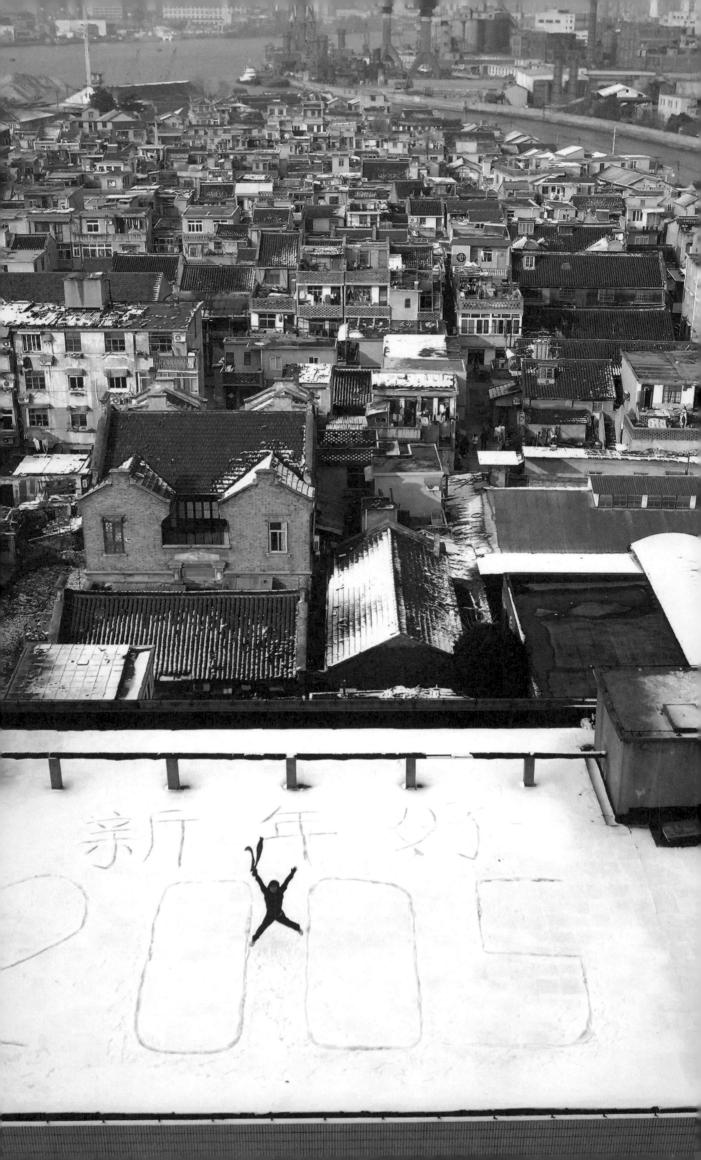

Shanghai had a snowfall on the eve of 2005. The Chinese characters xin nian hao on the snow mean "Happy New Year!"

light tower to the Garden Bridge, take the Yuan Ming Yuan Road, see some old houses, finally, get off at Yun Nan Road to have chicken porridge at the Xiaoshaoxing Restaurant.

"Twenty? That's more expensive than a taxi," we protested.

"To hell with a taxi. You won't see a thing. In my rickshaw, when you want to go faster, just tap your foot on the footboard and I'll go faster. If you want to see things slowly, eat some melon seeds, do some sightseeing, I'll pedal more slowly. Madams and mistresses of the past were just like that. They'd cross one leg over another, looking gorgeous. They wore American silk stockings, pulled up just right. People on the streets will watch you, too, as if sightseeing."

The old man's eyes shone under the light. He told us all the nice things about his rickshaw, quite professionally, and we laughed. I watched my jeans under the light and regretted very much I had not come prepared. I could not cross my legs on the rickshaw and reveal American stockings, shocking old Master Gao, who came to Shanghai to escape the Communists in the countryside. On second thought, where on earth could we buy those sheer stockings of 60 years ago?

The red rickshaw made a big turn on the small street where the Dutch Bank was located. Then we were on the big avenue along the riverfront. The wind felt damp on our faces. The bronze gate of the customs building was in the shadow of light and flashed by us in silence, as if in a peep show. The old man pointed at the bell tower and said, "The clock was made in Britain."

Buildings with red-tiled roofs are typical of the low-rise residences in what used to be the "Concession sections" of Shanghai.

There were many small lamps hung outside the East Wind Hotel, noisy and tacky. Children came out with red paper cups, with unfinished Coke in them. Now it is a favorite children's place, where they can have American fried chicken.

The old man said, "It was the most expensive place in the past, where Shanghai's richest people went for entertainment."

The old man's back arched up like a bird, his hands leaning flat on the handlebar, two legs up and down on the pedal. He was vintage Shanghai himself, like the old clock. He told us he started to pedal this rickshaw at 16; now 60 years had passed. He had been a young man from the countryside north of the Yangtze River. Now he was a stout old man with varicose veins all over his legs.

"In the past, we were quite good at telling what type of people they are and acting accordingly. When we saw trendy people, we said, 'Hello, hello,' in English; when foreigners used their sticks to knock on the pedal, we said, 'Hurry, hurry,' in English, meaning quick."

We were shocked—the old man spoke English!

The street lamp lit up the old man's face, and he smiled. "When passengers got off, we said, 'Good-bye, sir,' in English."

It was an extraordinary experience to see the city from the rocking rickshaw. We saw the old Signal Tower. It was small, looking strange, and uselessly placed at the end of the Bund. Big houses on the Bund, narrow streets without trees, damp air blown from the river—one felt as if one were traveling through

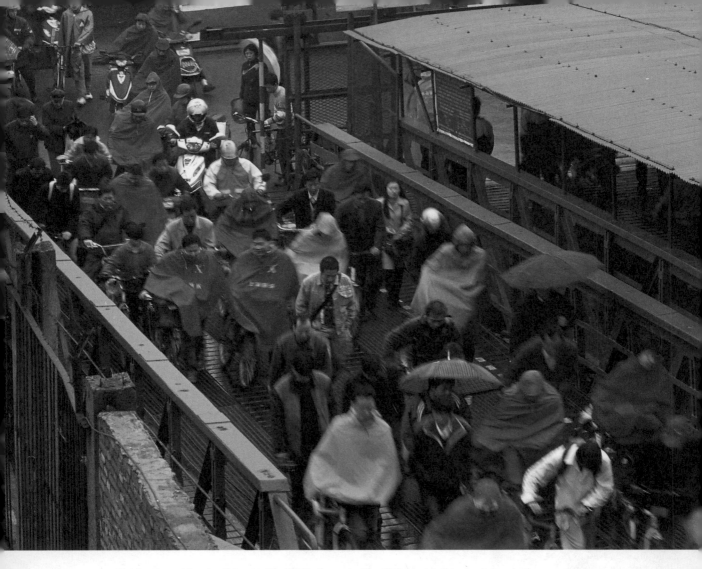

The hustle and bustle of the city life. While the majority still depend on bicycles (above), the car-owner population is on the rise rapidly in recent years (opposite).

100 years of Shanghai history. This was truly an extraordinary city. Everyone looked like the child in a nineteenth-century European novel, with a heart-shaped gold pendant hung from his or her neck. There was a picture of a blue-blooded lady in the pendant. The child was destitute and lived like a rat. Then one day he discovered that he was the illegitimate scion of a noble family. Now the whole city was looking for its own heart-shaped gold pendant. When we were small, wind from the river swept over the Bund in the darkness. Now the Bund was dressed up bit by bit. When night set in, the Bund lit up. It was like someone who had finally found a pendant; however, that person wasn't sure whether it was gold or not. He bit it and rubbed it in his hands, wondering.

"What exactly did the Bund look like in the past?" we asked.

"Much cleaner than nowadays. Foreigners took their kids here for a walk. On the Huangpu River, rich men's yachts made hooting and tooting sounds. It was a place for rich men."

Was it the life that people now aspired to, thought of, or believed that they once had?

"If you have money, things are fine. Without money, nothing will be right."

"What if you have money?" we asked him.

"Who doesn't want to eat, drink, and have fun?" the old man said in a loud voice.

Is it why people today all want to go back to the good old days? All of them, no matter whether they had money or not in the past, no matter whether they know or do not know exactly what the past looked like—they all say they want the past to come back.

—The Tricycle on the Bund

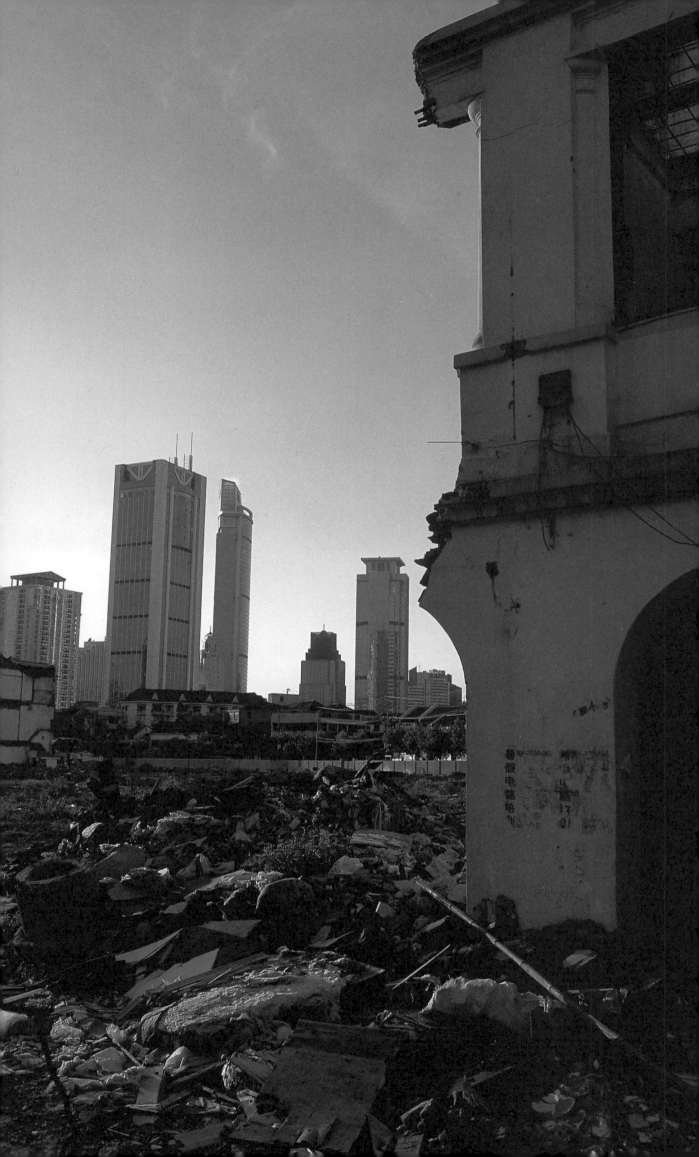

Skyscrapers of the 1990s rise up before the demolished old buildings.

One night I happened to pass the back street near where I live. On both sides of the street there used to be crowded old-style Shi Ku Men row houses; now they are being demolished block by block. Families who used to be crammed in here, with all the noise and dirt, are nowhere to be seen.

A high school classmate of mine used to live here. Her brother would lean on the oily dark kitchen door on the ground floor, eating last night's rice soaked in hot water and covered with some purple eggplant braised in soy sauce. Treading on the uneven kitchen floor and the steep staircase, I walked into her room barefoot. In the summer, the awful hardwood floor turned whitish after being mopped. When we sat on the humid floor, a single scratch with a fingernail could easily break the fragile veins of the deal. We smelled chlorine in the tap water of 1975. "Chlorine," she said. She was the class representative for our chemistry course.

Today lane after lane, piled high with rubbish, are hurriedly deserted in a rush. House after house, dirty and old, exude a smell of suffocating sourness, as if from newly perished bodies. A few doors and windows have been removed, and holes are left on the walls in the darkness of the night, looking like unwilling eyes that cannot close.

The squeaky sound from televisions and radios has disappeared, and all is quiet. In the past, while the neighborhood was dirty, noisy, and hideous, it was stimulating in its own way. Now the backstreets have become corpselike.

Above: A street in downtown Shanghai. One side of the street is cordoned off for yet another construction project. Opposite: Back streets like this could be next.

For the first time, a street lamp projected my shadow with no obstruction; it was very long on the ground and very untidy. My shadow covered a deserted worn black leather shoe, a white enamel spittoon, and a pile of gray broken bricks.

People said that it had taken a great deal of effort to demolish the buildings, even though they were so old and dirty. When the houses were built, a liquid made from glutinous rice was added to the cement to make the brick walls—that's why the houses were so solid. Now there is a light sound coming from the debris; it must be rats from the old houses. Those households that had fed the rats for generations had gone one by one. Those shops—oil-and-sauce shop, grocery shop, rice shop, and cigarette-and-paper shop—closed down one by one. The rats must be in a state of panic. The debris will surely turn into a big construction site, and the rats will all perish without a proper burial.

There was an oil-and-sauce shop next to the lane where my classmate lived. Vegetable oil and peanut oil were stored in big steel buckets, and there were oil stains all over the buckets. Dust adhered to the buckets to form light and gray strings, and the

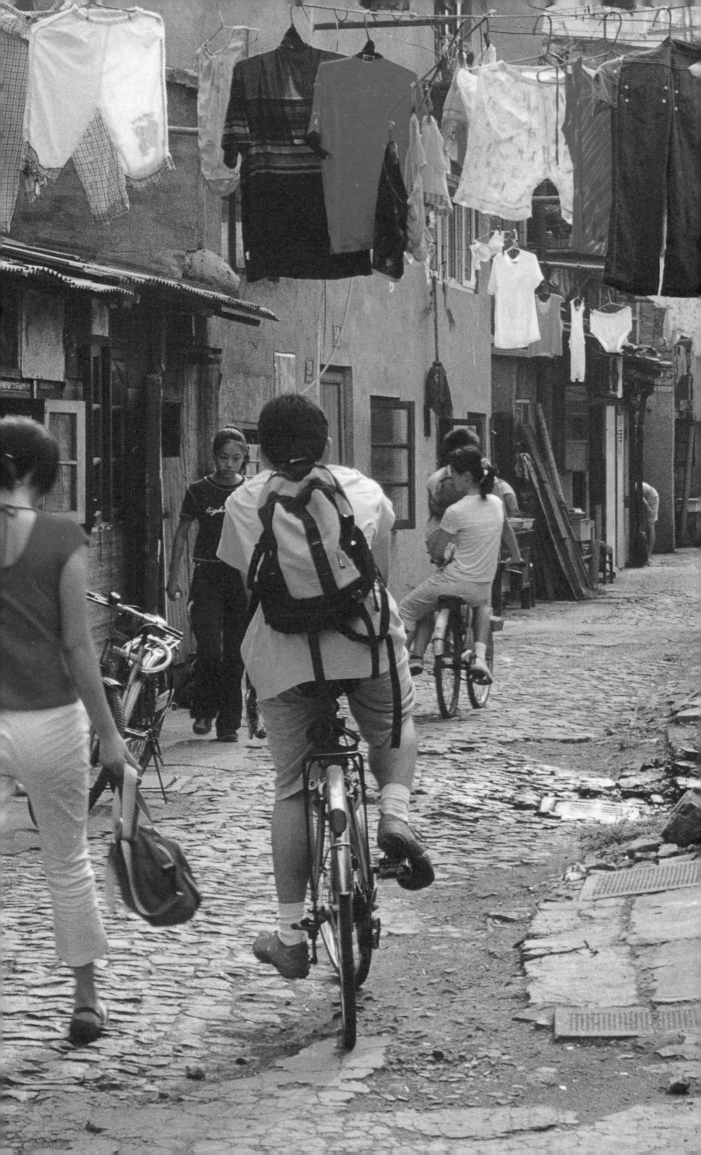

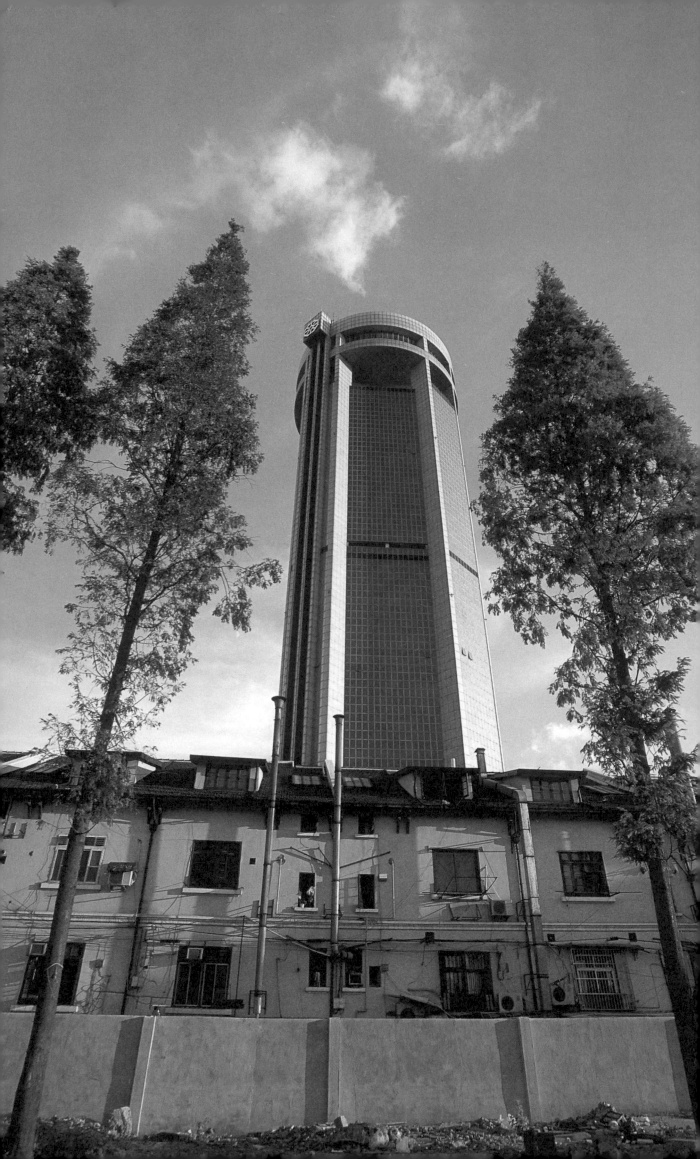

dust absorbed a lot of peanut oil and turned dark. One could buy one liang (a little over an ounce) or 0.5 liang of salad oil, just enough to make a portion of mayonnaise to serve one go of salad. The first time I made mayonnaise, it turned watery because I did not stir it with the chopsticks in one direction all the way through. The oilman had a cotton apron that was soaked with oil stains wrapped around his body. He was exhausted. His waist was slack, his hips were narrow, and he leaned forward to support the weight of his body. His figure had the typical shape of Shanghaiese men. Using a small funnel, he poured oil into each customer's bottle, not giving preference to anyone. He kept the steelyard level and would not allow its arm to rise even a little. If he was over by just a tiny spoon of oil, he would matter-of-factly pour the oil back into the bucket. Then, with his fingers, he would recover the little stream of oil that spilled on the outside of the bottle for the customer—he would not allow his customer to be even one drop short.

A mixture of old and new buildings.

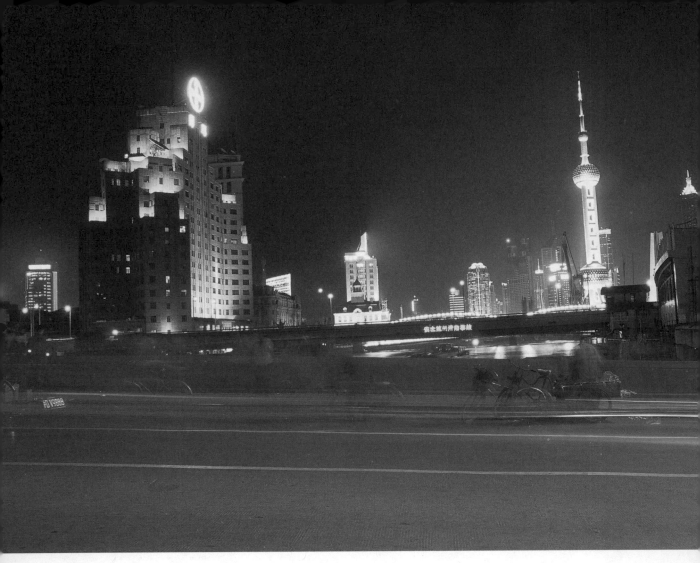

Above: The glitzy Bund night scene is in sharp contrast to the no-thrill back door of an old house (opposite).

Today the labyrinthine lanes have become only debris. Looking over the ruin, one sees the whitish street under the moon at the back of the houses. It looks like a Jewish ghetto in Warsaw in World War II films, and one feels a crushing sadness. The dark shadows of adroit house rats scamper over piles of debris like lightning and disappear into shadows in a split second, as did those Jews who ran for their lives.

There was another small lane next to the oil-and-sauce shop leading to my primary school. I think it was a primary school in the lane of the "chicken feathers flying to the sky" era. There was no classroom for music. Each time there was a music lesson, the teacher with freckles all over her face would drag an old organ into the classroom. In that small lane all shapes of wooden doors were wide open, looking like the holes of a beehive.

Those who lived there would keep their doors open all year-long to let daylight in. When they fried cutlass fish, they would make the tails very golden and crisp, and the lovely smell would fill the lane. They put peaches into bamboo baskets and hung the baskets on steel nails on the door frames. It was a habit they brought back from the countryside of Songjiang.

Bamboo poles were erected in the narrow, small passage-
ways, and wet clothes were hung there in all seasons, with water
dripping down. Students, especially boys, had to carefully dodge
those pants that were hung up high—people say that crawling
underneath someone's crotch will bring bad luck. At midday in
the spring, those who lived in the lane took out their quilts to air
in the sun. Solid and striped cotton sheets covered the quilts
that hung tightly together there, puffy in the sun, giving out the
reassuring aroma of dry, warm cotton. Under the quilts and in
old vine chairs, elderly gray-haired women basked in the sun,
looking content; there was the deep, thick smell of old women
in the air. They looked rather detached, perhaps resigned to their
situation.

When I was a child, this was a small lane with pleasing aromas, and
when I walked along it to go to school, the lovely lane made me want to
play hooky for the day.

—Passing the Corpselike Back Street

It was not until I came back from my friend Nicole's home that I started to notice my own cases. I just could not forget the pile of cases in her guest room, stacked opposite the door. They were like Chinese boxes, piled up one on top of another. There was an aura to them, a serene detachment that belonged only to worn cases.

Soon after that visit, I had to move to a new place from where I had been living since our move from Beijing to Shanghai. That was when I discovered how many things had been crammed into my tall, narrow closet. It was incredible. But my mum managed to find enough cases for me to pack up everything, and that is how so many cases came to be in my new place.

The largest one was a black leather trunk, older than I. It was bought in Nanyang—the old name for the area farther south of the South China Sea—where my parents were working right after my elder brother was born. The case was made of the skin of an Indonesian elephant. They took it to China, and when our family moved to Shanghai, they brought it with us. I had already started to form some memories around that time. I remember the evening we arrived at Shanghai, and the characters of the railway station were framed by neon lights that emitted a warm red glow in that cold night. I already knew some Chinese alphabet characters by then, and I knew Chen, my family name. When we were waiting for the car to take us to our new home, I was busy counting our cases. My dad had pasted some white paper on them and had marked them with CHEN 1 all the way to CHEN 7.

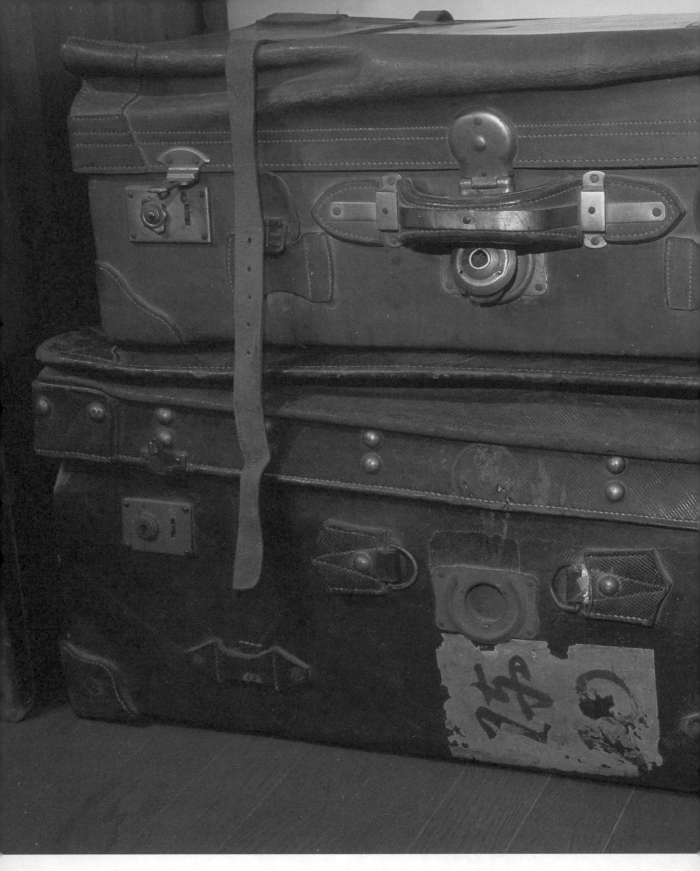

Above and following: All the suitcases bear witness to the history of the Chen family.

The big black leather case was the most eye-catching of all. In it were all the winter clothes we had brought from Beijing: my big brother's blue cotton-padded jacket, my younger brother's brown corduroy jacket, my own flowery satin cotton-padded jacket, and more.

We moved from Beijing to Shanghai and became Shanghaiese, just like that. Mum and Dad did not mind moving. When they were young, they had moved nonstop. Their furniture, even chairs for the kitchen, was rented from their work units. There were small green iron plates nailed to the legs of the chairs, indicating that they were public property. However, my parents always brought those cases with them—the cases were the only things that always followed the Chen family. But this was our final move; we stayed in Shanghai. Father's markings—the CHEN 1 to CHEN 7 series—have been left on the cases ever since.

In 1974, I returned to Beijing for the first time, to spend my summer holiday. Childhood friends took me to see the quadrangle where we used to live. I saw the big vermilion wooden gate from my memory, but no longer felt this city was home. The warm, fresh onion and garlic smells exuding from the northern households in the courtyard were no longer familiar. Everyone saw me as a Shanghaiese, but our big black case knew we were not. We were not Beijingese or Shanghaiese, but people who simply followed their cases. Even after the passing of so many years, that is who we probably still are. So when I placed the big black trunk in the corner of my own place, I instantly felt at home.

(continued on page 172)

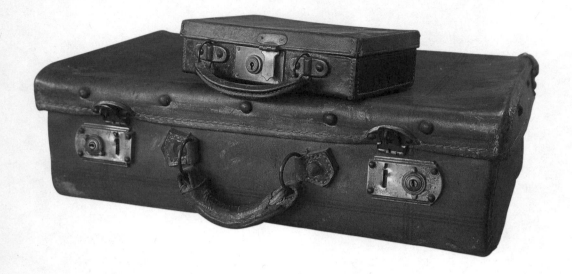

There was also an iron case that I loved to look at when I was a child. It belonged to my dad, and he bought it in Poland. Thirty years later I also went to Poland, and I brought him back a made-in-Poland aluminum-alloy walking stick—the very thing he needs now. While boarding the airplane, I noticed that the new Western-style cases were made of soft leather. Passengers carried them on their shoulders when they got onto the plane, and a stewardess hung them in the closets in the cabins. Alas, my father's iron suitcase was out-of-date and no longer in use.

The cases I brought with me from my mother's place are now standing near the dining table in a corner of my new home. When I get a moment, I wipe the dust off and admire them. I usually keep them closed, with the big rusted keys still in the keyholes. They fill me with a feeling of comfort, a sense of belonging to something. In my new place, with its unfamiliar smell and its quiet, so unlike the old house in our noisy old neighborhood, the cases are like the needle that calms the sea in *The Journey to the West*, setting my mind at ease.

—So Many Cases

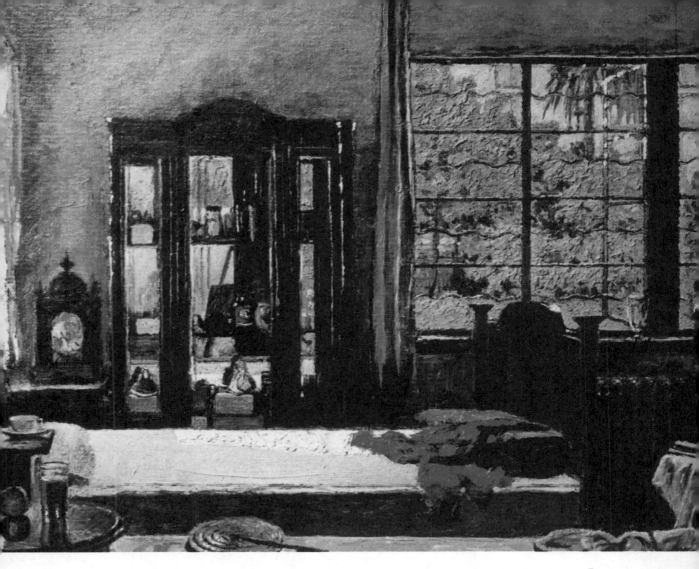

A painting of his own bedroom by Yan Wenliang himself in his old age.

The door opened, and it was dim in the old house. There was a smell peculiar to old houses, mixed with the breath of an old man, the pungent rosin on the oil canvas, the smell of warmed-over food, the dry pages of old books covered with dust, and the aroma of camphor and wood from the fading old furniture. There was a partition at the entrance and an old hanging lamp, shaped like a golden lily in reverse and covered with a glass shade, hung from the ceiling with a slightly rusted iron ring. The lamp reminded one of the new artistic lighting decorations in Paris at the turn of the twentieth century, after the city had survived the bloodshed. Indeed, the lamp had been brought from Paris by Yan Wenliang.

That year Yan Wenliang brought back more than 10,000 books on fine art and more than 500 plaster replicas of famous sculpture. He did not bring anything back for his family.

The drawing room was very dim in fluorescent light. There were two mirrors with golden frames on the wall, covered with dust, water vapor and oil stains, which were left there when the

oily steam from the dining table floated to the frames and stuck there. When the long golden candles near the mirrors were lit, a chest-high, exquisitely carved Rangoon teak shelf could be vaguely seen in the mirror. The shelf was placed there especially for a set of French encyclopedias. A leather-covered book with golden letters on the cover was not lying open on the desk; it was placed on the shelf, tilted slightly toward you. Behind it, there was a bookshelf filled with encyclopedias.

There was a big carved wardrobe next to the books, with rococo-style intricate patterns on the sides. It used to be in Yan Wenliang's bedroom, but now the bedroom became his granddaughter's bedroom and the wardrobe was moved to the drawing room. There may be some copper in the wardrobe, because greenish stains of corrosion could be seen in places. Even when he was studying oil painting in Paris, Yan Wenliang drank only tea in cafés. When he came back China, whenever he could avoid wearing a suit, he always wore Chinese clothing without shoulder padding.

However, in his bedroom, there was a whole set of Western furniture. He seemed to be a man who liked different things and knew how to choose the ones that best suited his life. He did not deliberately label himself one way or another.

It was from a little bronze bust in the drawing room that I saw what Yan Wenliang looked like. He was a long-faced old man with a slightly pouting mouth, who looked sincere and honest. I felt as though I had seen him somewhere before—an

Some of the articles Yan Wenliang brought back from France are still in use in his drawing room.

old man in an old gray cotton-padded coat. The front of the coat looked like that of any other casual old man; it could easily get dirty if the old man was not careful. I must have seen him at a certain time, in the lane, but I had no way of knowing then that it was Yan Wenliang.

He was the first man in China to ship a large number of Academy-style replicas of European sculptures back to China; that was in 1931. From then on, countless Chinese have benefited from his more than 500 plaster statues and learned something about the civilization of a faraway place.

In 1997, I saw *Boy Picking a Sting* in Italy, also in pure white. I remembered that many years earlier, when I saw a plaster replica of the statue in a corner of the warehouse in my school, my young, hungry heart felt like exploding; then I felt a sweet sadness.

It was not until many years later that I realized how deeply I was affected by art. In my school days the Western plaster models were no longer used in teaching. However, someone must have been very unwilling to get rid of the *Boy Picking a Sting* replica; the boy's face was blurry after having been remodeled so many

The old Western-style furniture in Yan Wenliang's home.

times. So it was simply stored there with unused Young Pioneers' team drums. Twenty years later I found my old friend in Italy. Seeing me, an Asian, at the museum, there were always kind people who would good-naturedly explain the ABC's of Michelangelo. And they were always surprised when I continued with the Dee's. They did not know that long before I was born, there was a Yan Wenliang in China.

However, it was not until now, standing in dim light of his drawing room, did I realize that my love of European art was implanted in my heart by Yan Wenliang, a man with small oily stains on the front of his coat. He would not have any idea that he had planted a seed in a lonely and rebellious heart just like that. Nor would he know how many people he had inspired. Perhaps he did not envision that today we know far more about European civilization than the Europeans know about the East.

Sometimes it seems unfair that we love Europe so much. Yan Wenliang worked so hard and bore so much difficulty in order to broaden the horizons of Chinese, hoping we would get stronger and be capable of the things that others were able to do. But

Yan Wenliang's drawing room.

often, in the eyes of Europeans, we Chinese study hard purely out of admiration for them. Did this subtle but important difference also hurt him?

The 500 plaster statues shipped back on a ocean liner from Italy to Shanghai turned the Suzhou School of Fine Arts, founded by Yan Wenliang in his hometown of Suzhou, into the best-equipped school in China. People representing fine art schools

from all over China came to Suzhou one after another to replicate plaster molds. The statues were displayed in exactly the same way as they would be in a European museum. People said the statues were to the world of fine art what those Buddhist scriptures brought back by the monk Tripitaka from India were to the world of Buddhism. That year a man named Xu Beihong, who had just came back from studying in France, took his wife, Jiang Biwei, to Suzhou and tried to persuade the 37-year-old Yan Wenliang to go to France to study painting, thinking that China would then have its own Meissonier. Xu Beihong could not have expected that Yan Wenliang would accomplish something that many other Chinese who went to France to study painting, and who indeed established themselves in the world of painting, failed to do.

In 1937 Japanese troops invaded Suzhou, and the Suzhou School of Fine Arts became the commander's headquarters. The Japanese soldiers used those plaster statues for target practice. In 1966 the Red Guards, in eliminating the "four olds," smashed the entire display room.

The original plaster statues brought back by Yan Wenliang from France were no more.

—Yan Wenliang's Drawing Room

Miss Shanghai

One of Schiff's Shanghai Girl paintings.

In 1996, I saw Schiff's paintings for the first time at Professor Kaminsky's and learned there was an Austrian Jew who once lived in Shanghai and painted the lives of the lower-class Shanghaiese. He was Schiff, and for a while in the 1930s, he lived in an old apartment building opposite the corner of the street where I lived. The faces of the Shanghaiese under Schiff's brushes—those broad cheekbones, cunning glances, and the ability of Shanghai girls to seduce, still live on the wide avenues and small alleys, in the pubs and restaurants frequented by foreigners, among the crowd enjoying the coolness of the night in the old districts during summer.

It is quite extraordinary that a foreigner could see through the optimism and clear thinking in the character of the Shanghaiese—those cunning and practical Shanghaiese. The Shanghaiese believe that with strong values and persistent efforts they can build a better, prosperous new life. Schiff did not see the Shanghaiese as robbers or eccentrics; he saw them as vibrant city people. He painted them with what must have been bewilderment and amusement. One can imagine that while he was painting, he could not keep from smiling.

In Schiff's youth he had some Shanghaiese girlfriends. The relationships he had with Shanghai girls must have been the inspiration for *Schiff's Girls*. One wonders whether the heartless and exuberant Shanghai girl in his painting was his first girlfriend or not. The girl spoke broad pidgin English but expressed her attitude toward life perfectly.

Me no worry, me no care! Me go marry millionaire!
If he die, me no cry! Me go marry other guy!!

The Shanghai girl had a round face, typical of the southern Chinese. With long, narrow slanting eyes, she had a somewhat earnest expression—also typical of girls in the regions south of the Yangtze River—along with the pride and sharpness typical of Shanghai girls. I laughed in my heart: Schiff was indeed a clever guy. If he weren't so clever, first he would have painted the girl as more flirtatious and been wide of the mark; second, he would have revealed his grudges.

It is said that Schiff not only had pretty Shanghai girls as girlfriends, but he also had a not-so-easy love affair. He was in love with the young wife of a general and always kept her picture. She was very pretty. I heard that the picture was among the things Schiff left when he died, but I did not find it. I found instead many name cards he had gathered while in Shanghai. I saw from those name cards that at that time, phone numbers in Shanghai were five digits. I read the letter he sent from Shanghai to his family in Vienna. On the envelope there was the stamp of the

(continued on page 193)

MISS
SHANGHAI

ME NO WORRY—
ME NO CARE!
ME GO MARRY
MILLIONAIRE!

IF HE DIE—
ME NO CRY!
ME GO MARRY
OTHER GUY!!

Opposite: A photograph of the artist Schiff. Above: One of his Shanghai Girl paintings.

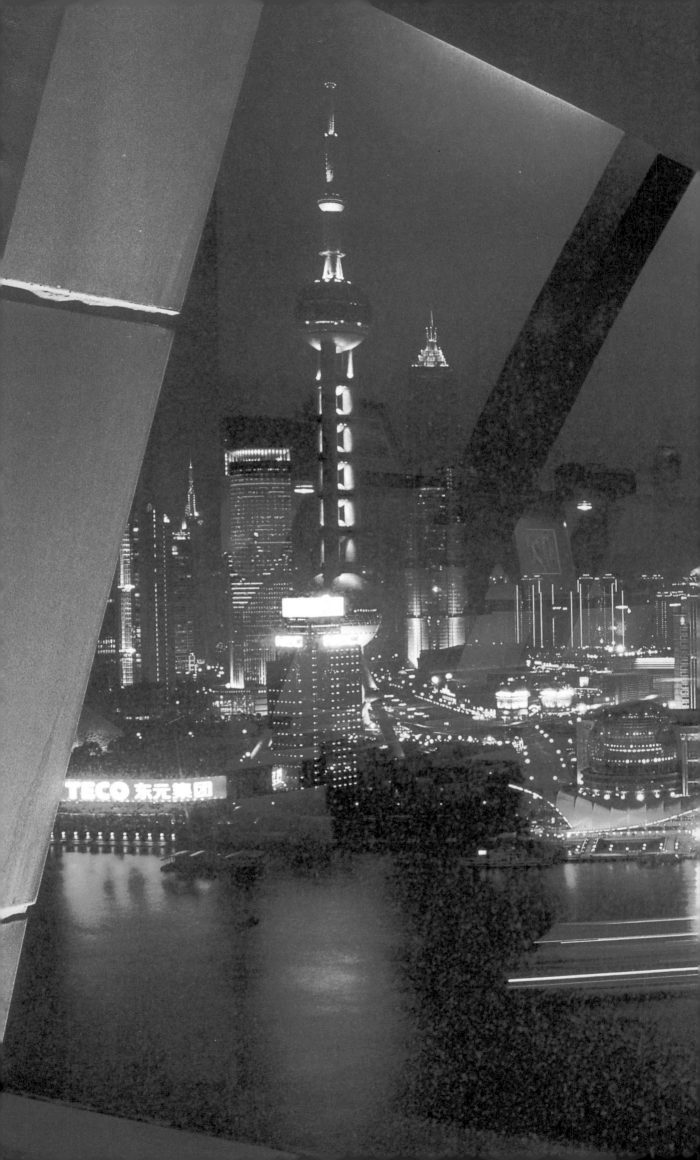

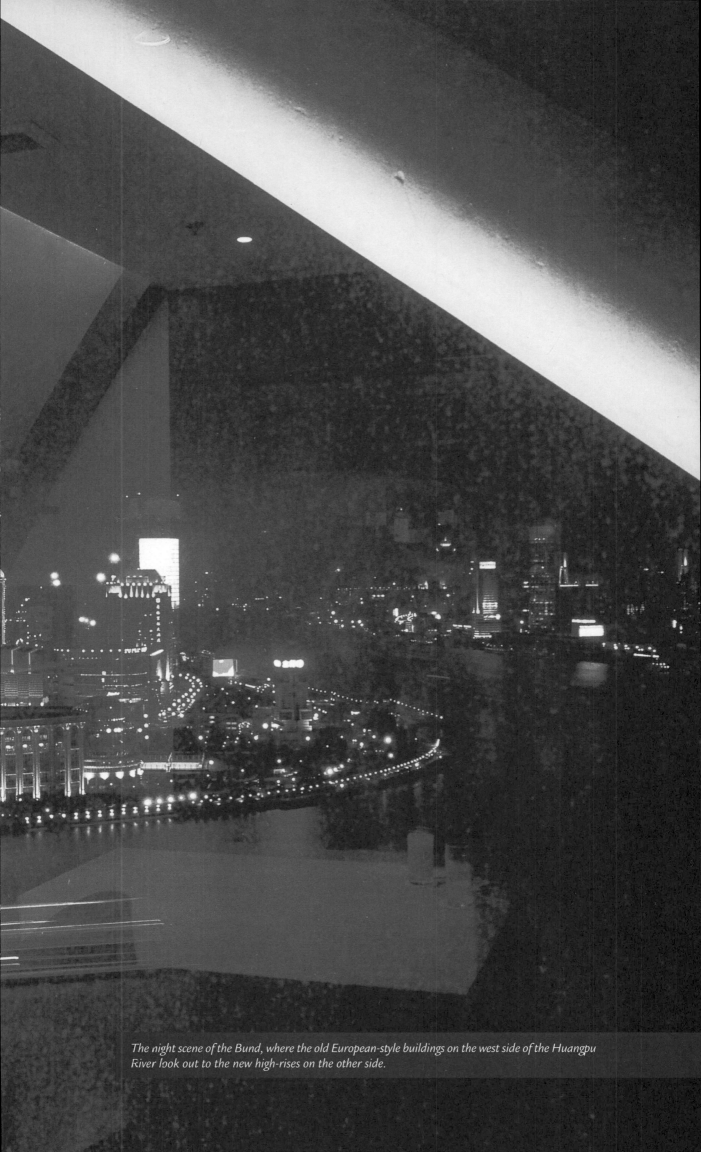

The night scene of the Bund, where the old European-style buildings on the west side of the Huangpu River look out to the new high-rises on the other side.

La Femme chinen

Above: Schiff's rendering of the Bund. Opposite: One of his Shanghai Girl paintings.

Shanghai Post Office, as well as the stamp of the Reich. At that time Austria had been annexed by Nazi Germany, and Schiff moved from the old apartment opposite the corner of my street to a house on Yuyuan Road. The address suggested that it was near Hongye Garden. I looked at those slim and fashionable Shanghai girls painted by Schiff and thought that those lovely figures might have come from his memory of that general's wife.

Later Schiff returned to Vienna and died there. However, he remembered that the best days of his life were spent in Shanghai—those young, busy, happy days. He had been to Beijing, Japan, and South America, and he had painted those places, too. However, no matter what, even when he painted his hometown of Vienna, even when he painted Paris, the most beautiful city of Europe—those paintings were no match for the way he painted Shanghai, with its vivacious spirit and vividness. What he painted best was Shanghai. And of all those Shanghai paintings, what he painted best were those urban girls who had long waists and slim bottoms, who were cunning but friendly, who were as soft as noodles but also as heartless as inanimate things.

—Schiff's Girls

M iss Du wore little. Not wearing cotton-padded clothes in
winter has been a tradition of many Shanghai women;
the extra layers of clothing hide their figures. In winter they do
not often stretch out their arms to shake hands, because their
hands are icy cold.

There came a woman with a pallid, yellowish face, wearing a
long, deep-red mohair dress, carefully knitted. The collar of her
dress resembled a small shawl, with a circle of mohair tassel
sewn to the edge. She wore nylon stockings. When the stockings
rubbed her wool skirt, heat was produced; this drew the skirt
tightly to her legs and made her legs look like a dough stick that
had not been properly twisted for cooking. She walked down the
street just like that, all creased but in a grand style, holding a
small, poorly made black bag from Fujian. The sallow-faced
woman made Miss Du laugh to herself secretly. However, the
grandness and desire shown by the woman felt familiar to Miss
Du. That was the atmosphere of a street like Huaihai Middle
Road. It was just like being a star onstage, watching people in
platinum necklaces and evening dresses who had come to see
her dancing.

Miss Du happily and provocatively passed the other woman.
She had a glimpse of the woman eyeing herself from under a
pair of eyelids that had black lines sewn into them. The other
woman looked dispirited yet unyielding. This situation was like
playing military chess. The adversaries gracefully march toward
each other, facedown. When they confront each other, the

Above: A modern-day Shanghai miss. Opposite: Schiff's Shanghai girl.

opponents turn the face of the chessmen up. With eyes like electric currents, they attack and the junior chessman is immediately out of the game.

There is an extension from the eyes, and it is the weapon of pretty women on Huaihai Middle Road.

It is a tool for appreciation, examination, aspiration, calculation, slight jealousy, fighting without showing any emotion, and naturally following role models. All these attract Shanghai women to that part of Huaihai Middle Road from Changshu Road to Xizhang Road, a two-kilometer sidewalk lined with Chinese parasols. It is their Piazza Navona of Rome. Sometimes it is a modern Navona: The Italians now have fashion shows there every year; in Shanghai women display this season's fashion to the city at the side of the road. Sometimes it is an ancient Navona: The Romans compete on the piazza, while the Shanghai ladies compete at the side of the road.

This is a large group of women, and there is one in each generation. These women are responsible for the fashion tends. In 1974 they wore blouses with big pointed collars and, in 1975, homemade flared khaki pants. In the winter of 1978, they made long, narrow cotton coats covered with nylon lining and sewed many rhombus grids on them with their sewing machines. In the summer of 1982, they wore cotton skirts, cut straight down and pinned with big buttons. Then came tight black pants with a piece of semicircle-shaped cloth at the end of each leg for the

(continued on page 200)

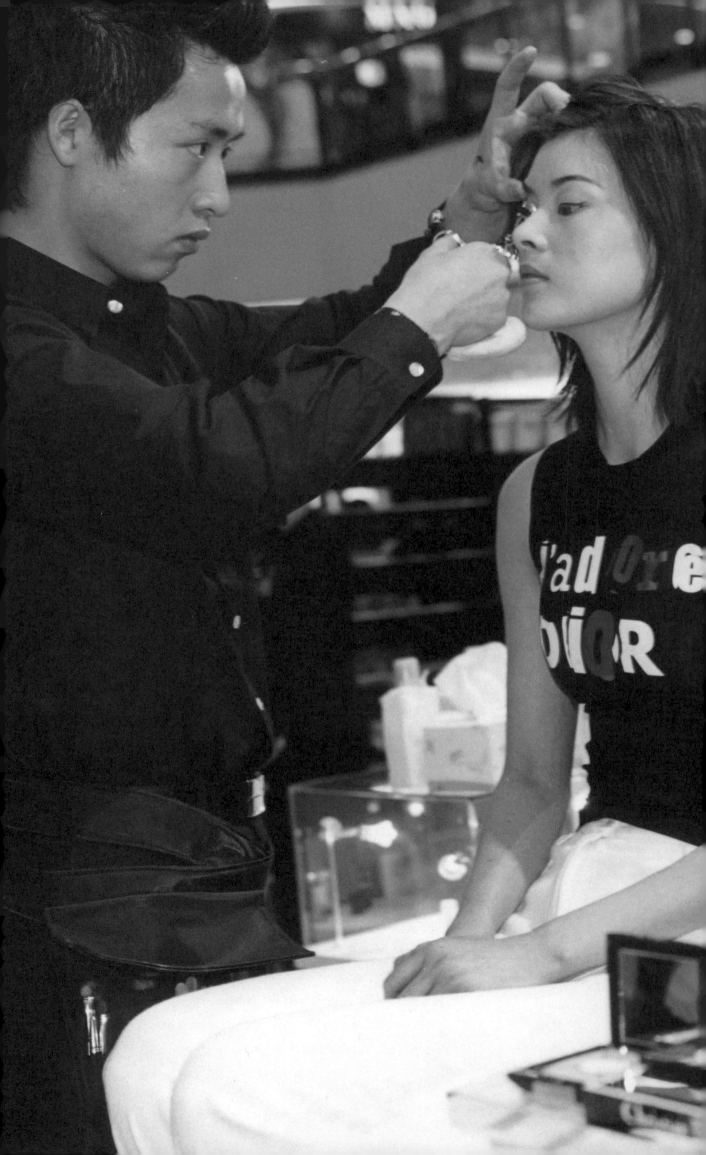

A Shanghai miss with her makeup man.

Young Shanghai women on one of the city's chic shopping streets.

foot to step on, followed by short tops that revealed the navel.

In the winter of this year, black narrow-legged pants are in fashion, along with Italian-style leather boots with duck-billed fronts, to go with short, loose wool coats. Hair is dyed light brown, worn straight, and lips are not too crimson.

Women walk on the road, one after another, to find their true opponents and the like-minded. They enjoy the pleasure of intimacy born of rivalry and comradeship. They pursue their interests and tastes, and keep their materialistic dream alive. Huaihai Middle Road is of particular significance to those Shanghai women.

> Sometimes, to take a walk here is a way to get rid of gloom. It all becomes a game of amateur competition, a lifetime school and a salon without a roof.

People on the road often wear styles that were fashionable in Europe in the past. But if you took a closer look, you would see that most Shanghai women tended to wear 9/10-length pants of not-so-bright colors. And they wouldn't wear pants that tightly

hugged their legs. European women often bought pants a size smaller, while Shanghai women normally bought them a size larger.

Shanghai women dyed their hair, too, but not orange. Usually they went with a subtler light brown or just a tint to make their hair look a bit reddish. As for flared pants—girls wearing them looked rather reserved and contented. They just wanted to wear a pair of trendy pants; they did not really care about psychedelic drugs, the Beatles, free sex, and the antimaterialism rebellion associated with flared pants. They were not Storm and Stress youths or their later-born followers. They just used the pants as symbols of extravagance and fashion on Huaihai Road.

European fashion is now carefully transformed into Shanghai's own fashion by its more confident women who know what they want. Shanghai women really know how to give and take, how to adapt things, local or foreign, to their own standards. They synthesize everything into a tailor-made Huaihai Middle Road fashion—a "middle way" that is distinctive.

—A Place Where Shanghai Women Meet and Rival

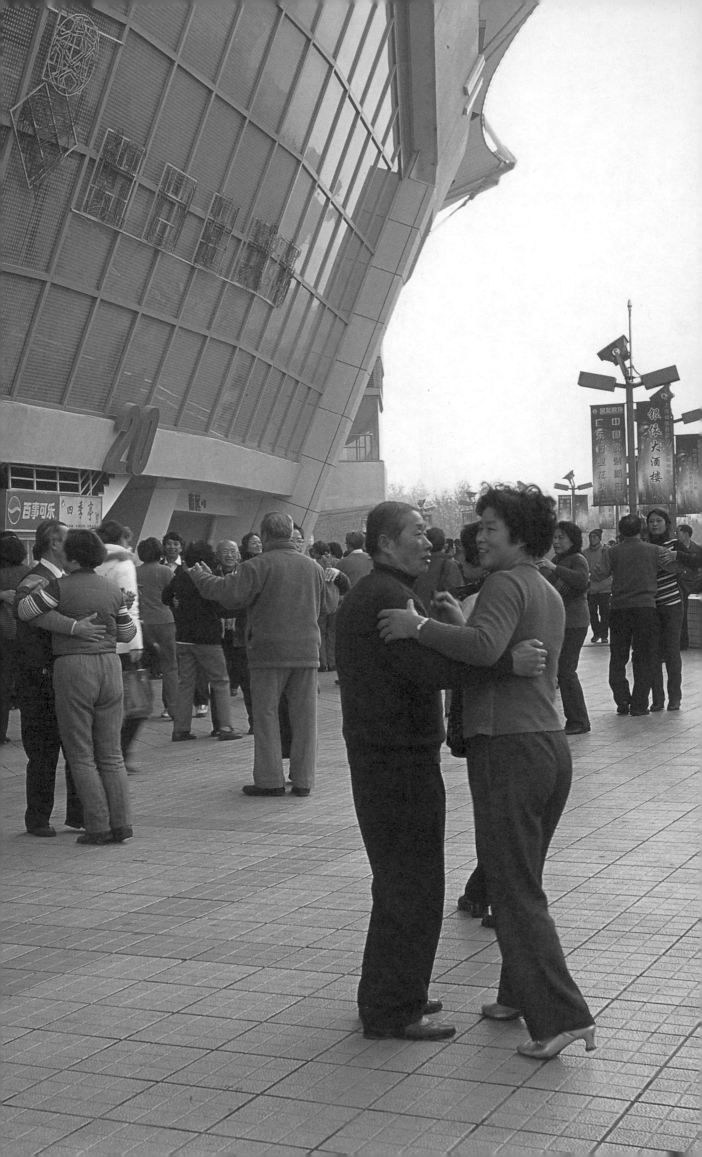

When they dance to the music and get close to the chain of small and dimly lit colored lamps, their faces are illuminated. Those are quiet and attentive faces. Even when their backs are lit up, we see that these are silent, hardworking backs. Even when the couples are dancing, their enduring strength does not go away.

We notice a dancer who is not very good; she cannot keep up with the pace, and the couple stops. Her partner chants "One, two, three, four," and she holds the man's hands tightly and shyly. Step by step she tries to follow him, stumbling a bit, and just as she begins to do better, the piece stops. She raises her head and smiles apologetically, her hands still clutching her partner's shoulder. He does not let go of her, and they just stand there like that. When the next piece begins, they tilt their heads to listen, like a pair of birds, and after a while, when they feel the rhythm, they resume their dance.

Onlookers shout loudly and encouragingly to them: "Not bad, not bad. You learn quickly."

Everyone here has something in common—no one has any money. Everyone just wants to dance; there is no other reason to be here. In the park no one is thinking about making a fortune.

"The friendship dance" became popular again in the 1980s. As time goes by, the young people seem to have lost interest in it, but many middle-aged and older citizens still like this kind of social dance.

Dancers of the 1940s as drawn by Schiff.

Shanghai of today is not the Shanghai of the past; now many people have money, and money has become more and more important. In the past the lives these dancers had were just a little bit out-of-date. But now, when compared to the lives of the wealthy, theirs look pitifully dim. Many people hustle day and night to improve their lives, but these dancers have no incentive to compete.

Even though they do not have money to enjoy the attractions of the city's nightlife, they do not want to stay at home, either. They still want a bit of music, a bit of social contact, a bit of fulfillment. No matter how little they can afford to do with their lives, there is always the excitement of a slow dance with another person in the dim starlight of the city, under the trees.

In many small parks in the center of Shanghai, there are such dancers. They go around from park to park until they find the one that has the music and atmosphere they like best. Unless the weather is very bad, the dancers hurry to the park immediately after supper. Since there is no electric power outlet in any park, they must connect a wire to a nearby house and then, of course, share the electricity bill. However, the dancer who brings the cassette recorder does not have to contribute.

During breaks in the music, they chat with one another. But if someone wishes to be alone, no one intrudes on his or her solitude. This is an unspoken rule—if someone does not wish

to speak, you don't make him. The dancers respect the space many of them need in order to cope with the trials of their unfortunate lives. Often you see women sitting on stone stools and men standing off in the distance. The leaves on the trees rustle above their heads, wafting the sweet aroma of plants.

Then they dance again. The woman who is a new learner still stumbles, always staring at her feet, as if walking. Her partner still chants the rhythm for a slow fox-trot or a lyric waltz.

There are also couples that simply come to walk hand in hand in the park and watch the dancers. Perhaps the music reminds them of something, but they aren't interested in dancing—they just walk away. In the eyes of the lovers, life must be perfect.

After nine o'clock the dancers gradually take their leave. Since many who live far away have come to the park by bicycle, it is time to reclaim their bikes, which have been left just outside the park, fastened with several locks. (There is the constant fear that the migrant workers in Shanghai might steal them.) Now it's time to ride home to sleep.

—The Dancers in the Park at the City Center

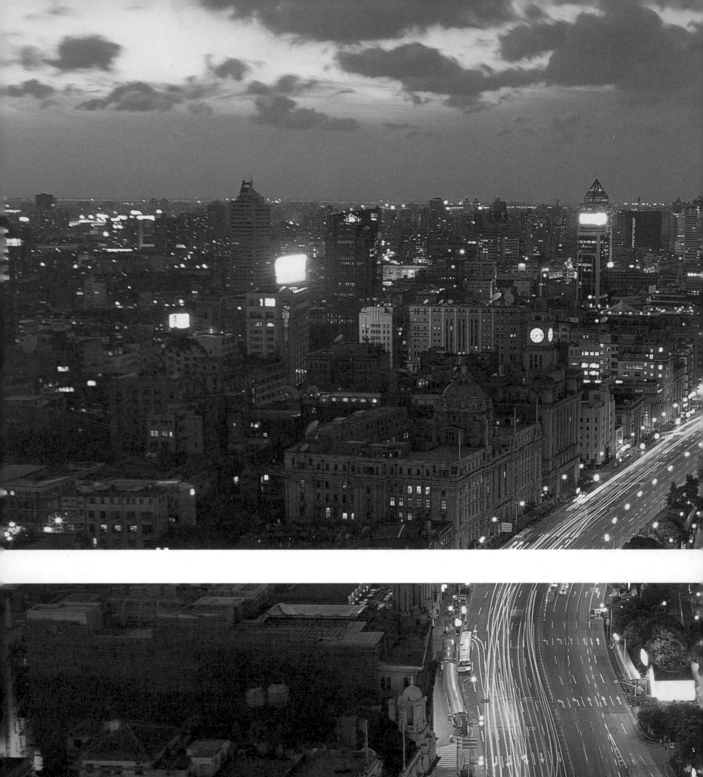
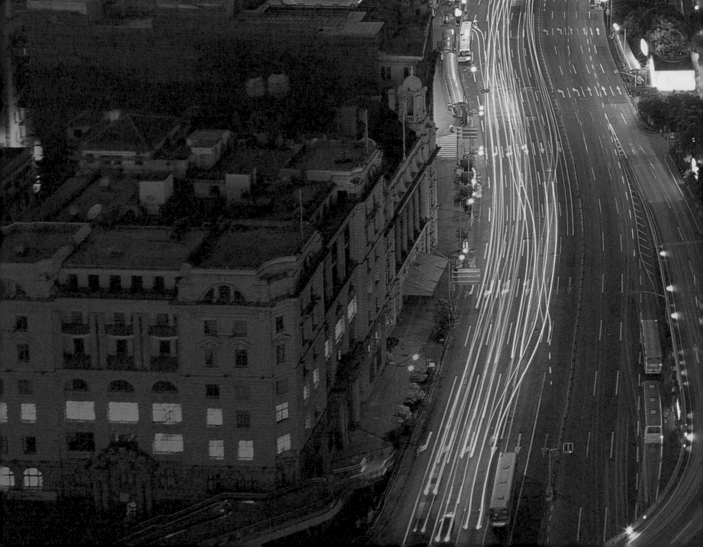

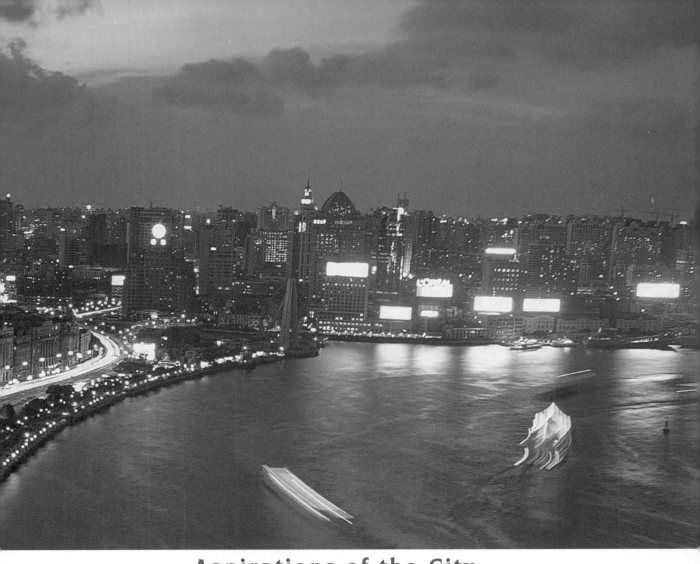

Aspirations of the City

One of the earliest docks in Shanghai, which is still being used today.

Shanghai has always been a city of aspirations. It has never had the serenity, complacency, and harmony typical of the regions south of the Yangtze River. The way of Shanghai is a world apart from what was captured by Chinese traditional poetry. Shanghai has aspired to assert itself in the cosmopolitan world. The city was born into an imposed cosmopolitan environment, like a mixed-blood child.

A late-night scene in Shanghai. People poured out into the street after a rock concert. With regular performances like this, Shanghai is fast becoming a "nightless city."

It is neither a typical Chinese city nor a typical French city, although the culture and the look of Shanghai have indeed been deeply influence by the French Concession.

Shanghai's businesses and infrastructure were more often British, but its lifestyle had inexplicable but complex connections with French influence. There were those churches, schools, and hospitals built by French missionaries. And there were the white Russians who stayed in Shanghai due to the strenuous efforts of the French, the viscount who escaped the Red flag in St. Petersburg and who was proud of his collection of French Impressionism paintings, the ex-admiral of the czar's navy, the aristocratic mistress who spoke French the way Anna Karenina did, the former pastry maker of the palace, the wet-nurse of the princess, the ballet dancer, the violin teacher—all these people made the French Concession very French.

The Aurora University opposite the French park produced Shi Zhecun, an old man of letters who looked up to French culture all his life. After many years of ups and downs, at 97 he still keeps a small bottle of French cologne, still likes to have a cigar,

(continued on page 213)

Shanghai's earliest floating dock is still in use today.

A scene at one of the outdoor cafés in Shanghai, where you can find people reading English-language newspapers.

and says the wish of his life is to pay a visit to France. Many years later Aurora University became Shanghai Medical Institute. There is still a class with lectures in French.

Shanghai is not a typical Japanese city either, although the Japanese left many houses with shrines in the Japanese Concession in the east of Shanghai.

At that time there were more Japanese than any other foreign residents. In Hong Kou district there were Japanese wagashi shops, kimono shops, sushi shops, bookstores, temples, schools, auditoriums, and cinemas. Anything one needed to live a very Japanese life could be found there, just as it was in Japan. Shanghai's left-wing tradition had numerous ties with Japan, and it was truly a powerful force that had influenced Chinese culture and allegedly represented one-half of Chinese culture. As for the wish for "total world harmony" painstakingly advocated by the *Modern* magazine, which had Aurora University behind it, it would surely have been crowded out by the left-wing culture even without the Pacific War. Today, in Hong Kou, that which has been rebuilt earliest are things—old things, former residences, cafés, and a Japanese bookstore—closely associated with left-wing men of letters because of Lu Xun.

It is certainly not a typical American city, although American architectural style can be seen everywhere in the buildings of the old districts.

Shanghai is fast becoming a modern metropolis in China, where one can enjoy the beautiful voice of great classic opera singers like Andrea Bocelli (above), and where international model contests are held (opposite).

Even on the Bund, Shanghai's most important landmark, those skyscrapers, though one size less than buildings in Manhattan, allow people to see the American style. American missionary schools were the most trendy and influential schools of Shanghai. Their graduates have proved with their lives that their alma maters had given them some beautiful and important qualities: openness, optimism, tenacity, and confidence to go anywhere in the world. American movies used to be the most important entertainment for Shanghai's youths, for both those urban youths on Avenue Joffre and the young workers and their girlfriends of Zhabei district. The vibrant and upbeat American idealism was the important calcium in the bones of Shanghai. American songs were the fondest childhood memories of many people. Even today, the alternating black and white tiles, the American style of the '20s, is still seen in washrooms and kitchens of Shanghaiese households in the central districts of the city. An affection for and an affinity toward America were present in the hearts of a whole generation.

Shanghai is not a typical Russian city either, although its lifestyle, food, and artistic style have greatly benefited from the presence of White Russians from St. Petersburg, who survived, then escaped the Russian Revolution.

Many details of life in Shanghai—the salad popular among many households, the borscht in Western restaurants, the style of locally produced Western paintings, the music academy, the ballet house, even a sad longing for Europe as if it were home—were implanted in the city by White Russians. Those Shanghaiese who became masters in translating Russian literature all had Russian teachers in exile to teach them elegant Russian.

Shanghai has not been a typical Chinese city for a long time. It is only right for Shanghai to go back to a mixed-blood environment.

For many years, even during the Pacific War, right after the Japanese left their Concession, the Japanese showed *Opium War* in Shanghai's cinemas, trying to prove that it was they who liberated the Chinese from the oppression of the Western powers. The Japanese advocated the so-called "East Asia Common

(continued on page 218)

Shanghai's Pudong International Airport is becoming one of the busiest airports in China. It seems that nothing can deter Shanghai's desire to march forward into the world.

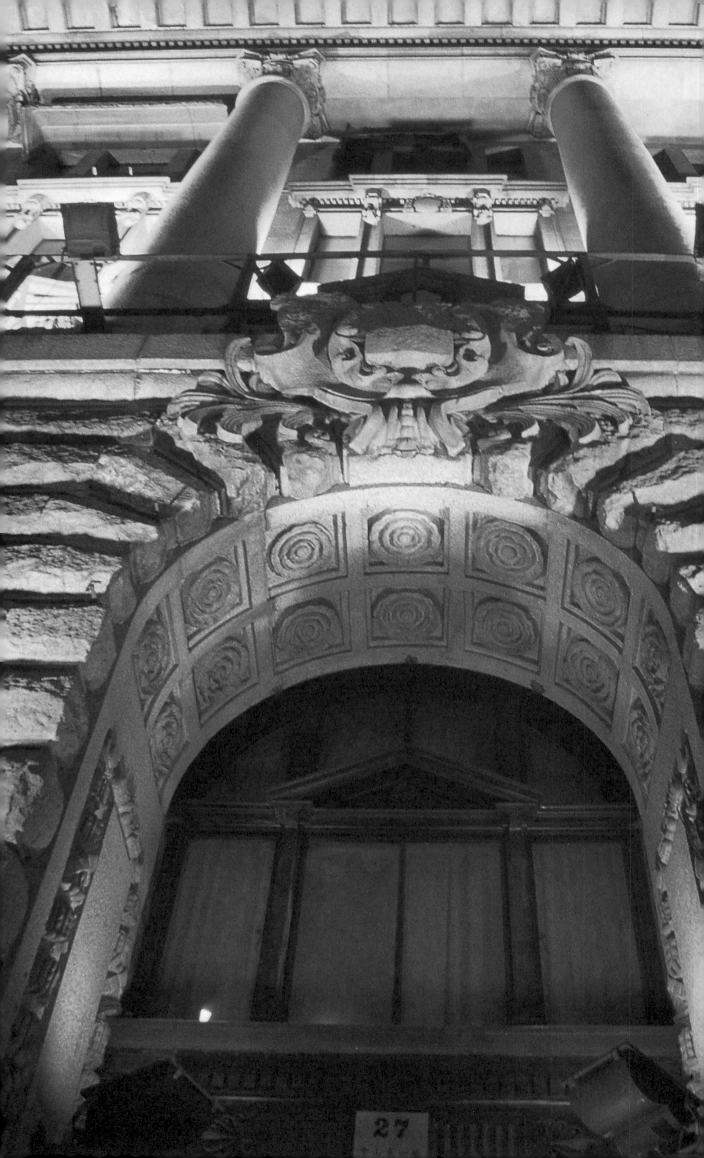

Jardine Matheson & Co. was once in this old building on the Bund—a most solid and somber building.

Prosperity Axis." However, at that time Shanghai's aspiration was to return to a diversified society, comprised of many nationalities and races. Its longing to be truly metropolitan, universal, or global was truly from the bottom of the heart.

Unlike how Hong Kong feels about Britain, and Saigon feels about France, Shanghai misses the whole Western world.

Yes, in the heart of Shanghai, there is a sense of inferiority and an anxiety, similar to how mixed-race people feel. This feeling comes from Shanghai's difference from other Chinese cities, as well as its difference from other world cities. Among China's cities, Shanghai is a peerless cosmopolitan city, and at the same time there is a deep-rooted loneliness, a feeling of panic, a sense of inferiority and guilt.

All this makes Shanghai sometimes eccentric—it is never as self-confident as Beijing, as broad-minded as Xi'an, as appealing as Hangzhou, as crisp as Guangzhou, or as composed and wise as Chengdu. On the surface Shanghai looks cunning and sharp. But at heart, it cannot help feeling bad about itself. This is why the Shanghaiese are often mocked by other Chinese citizens, while it is rarely seen that the Shanghaiese criticize others in public.

No matter what, nothing can deter the city's desire to march forward into the world, as a fish has to go back to water. Shanghai's embarrassing dilapidation and decay in the era of closure only give the city more motivation to march ahead.

Shanghai advances toward the world with lightening speed—
that's why its progress is so startling. Countless stores spring up
around the city, numerous as raindrops—shops selling the world's
finest products, American coffee shops, French perfume shops,
Japanese restaurants, stores selling top-class Austrian crystal,
Indian restaurants, German banks. There are Italian cars and Swiss
watches. The skyscrapers in Pudong rise up one by one, more
quickly than the bamboo grows in spring. While the world's
passenger air traffic declines in a free fall, the international flights
departing from and arriving at Pudong International Airport are
often full. At night, pubs are fully packed with foreigners speaking
English with all sorts of accents. When one sees all this, one cannot
help feel the intense hunger behind all this vibrancy. It is a need
to be again integrated with the world.

—The Aspirations of Shanghai

Aspirations of Shanghai and the Shanghaiese, who welcome the coming of another year with fireworks on New Year's Eve.

Picture credits & Acknowledgments

Shanghai Literature & Art Publishing Group

Chen Danyan
12-13, 28, 45, 52, 79, 80, 94, 100-101, 125, 130-131, 138, 139, 140-141, 228